DRAWING BOATS AND WATER

To Jean,
 wishing you many
happy painting hours,
 from Elsie & Gad.

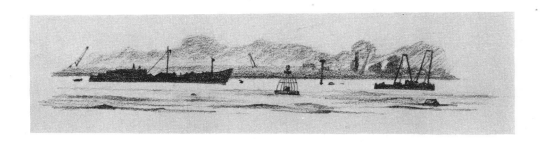

Companion volumes
ANATOMY AND LIFE DRAWING
DRAWING ANIMALS AND BIRDS
Don Davy

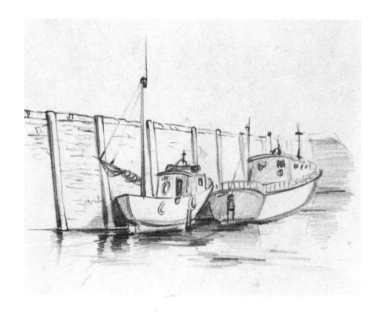

DRAWING BOATS
and WATER

DON DAVY

BLANDFORD PRESS

POOLE DORSET

First published in the U.K. 1980

Copyright © 1980 Blandford Press Ltd,
Link House, West Street,
Poole, Dorset BH15 1LL

British Library Cataloguing in Publication Data

Davy, Don
 Drawing boats and water.
 1. Marine drawing
 I. Title
 743'.8'37 NC825.M/

ISBN 0 7137 0984 7

Typeset by Dorchester Typesetting Co. Ltd. in
'Monotype' Perpetua.

Printed in England by Staples Printers Rochester
Limited at The Stanhope Press.

Contents

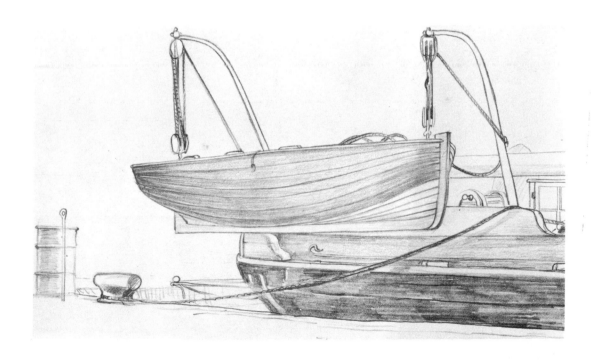

Acknowledgements

The Rt. Hon. Edward Heath, M.B.E., M.P.
The National Maritime Museum
The Royal Naval Dockyard, Portsmouth
The Thames Sailing Barge Society
Betty and Roy Burlinson
Sylvia Davy

Elaine Alderson
David Chalwin
Fred Webb for technical advice
Peggy Pollock and staff, the Leatherhead Library
All my friends in the USA and Australia

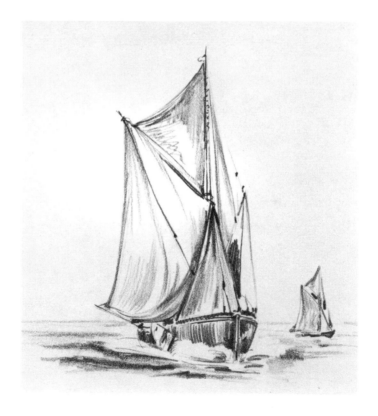

Introduction

For various reasons most people seem to be fascinated by water, whether it is just to look at it, swim in it or to sail upon it. With rivers and oceans perhaps there is a dreamlike expectancy of travelling by boat or ship to far off places. Whatever the source of the attraction, certainly artists have always had a desire to draw and paint boats, water, movement and reflections.

Water has a primitive capriciousness which demands our respect because there is an ever present element of danger. This, coupled with the wind, light and shade, gives us the basic excitement and wish to portray and capture its moods.

The beauty of water can be seen in myriad aspects, the still sombre lake, the happy bubbling stream, the roaring breakers and grand swell of the oceans. This, blended with the mirror effect caused by clouds and colour of the sky, plus reflection of boats and landscape, gives us much to study, learn, draw and paint.

'Messing about in boats' is a universal pastime, whether in a small boat on a pond, sailing a dinghy on a river or cruising on a majestic ocean liner. Enjoying the grandeur of the giants of the ocean is coupled with the awesome thought that even these great pieces of machinery are but an infinitesimal dot on the breast of our vast oceans.

In the following pages, various approaches to the study and drawing of water, boats and ships are suggested, as well as leads to picture making which brings in the necessity of studying all the extra paraphernalia such as bridges, docks, river banks, and locks, to make our picture authentic.

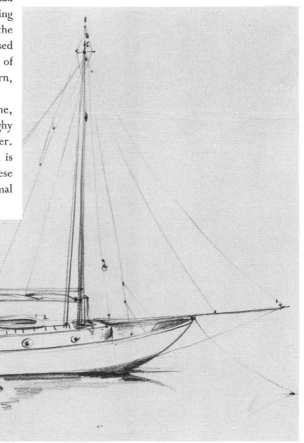

TO ALL MY STUDENTS

'We know clearly that the sight is one of the swiftest actions that can exist, for in the same instant it surveys an infinite number of forms; nevertheless it can only comprehend one thing at a time. To take an instance: you, O Reader, might at a glance look at the whole of this written page and you would instantly decide that it is full of various letters, but you will not recognise in this space of time either what letters they are or what they purport to say, and therefore it is necessary for you if you wish to gain knowledge of these letters to take them word by word and line by line. Again if you wish to go up to the summit of a building it will be necessary for you to ascend step by step, otherwise it will be impossible to reach the top. So I say to you, whom nature inclines to this art, if you would have a true knowledge of the forms of different objects you should commence with their details and not pass on to the second until the first is well in your memory and you have practised it. If you do otherwise you will be throwing away time, and to a certainty you will greatly prolong the period of study. And remember to acquire diligence rather than facility.'

Leonardo Da Vinci

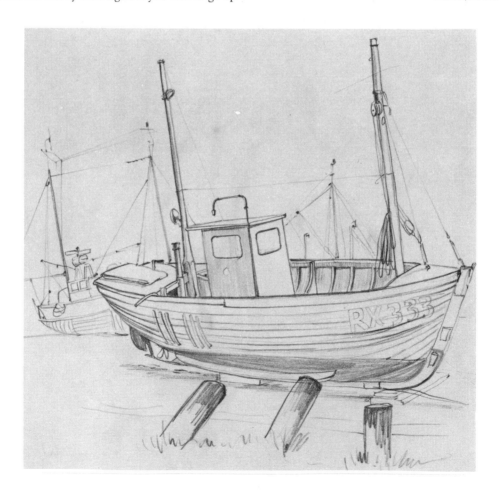

Preparation

To give ourselves the best possible chance of achieving good results in drawing, it is advisable to look to the tools and equipment necessary.

First of all we have to decide where we are going to begin drawing and one of the obvious observations will be that most of our work will be out of doors. It would be most convenient if we could always arrange a warm summer's day with no wind and to be cosy and comfortable, but for some of the work we will wish to undertake it will be necessary to choose blustery, cold weather. Therefore, on such occasions we must ensure that adequate protective clothing is worn to keep us warm and, if possible, some sheltered spot chosen to work from. It is not easy to draw when you are shivering.

Next for our comfort a flask of something to drink is a great reviver and will keep us alert and able to concentrate on the task in hand.

A collapsible stool is useful, preferably with a back to it. You can never guarantee the presence of a convenient upturned crate, pile of rope or a boat to sit on. Having now settled ourselves down, warm and if possible sheltered, we must consider our tools. A sketch pad or drawing board and paper is our first requirement and it is useful to have a supply of bulldog clips to hold the paper in position. They are stronger and more positive than drawing pins. Then we need pencils – two or three at least are recommended, already sharpened so that time is not wasted when we start work. A selection of B, 2B and 4B are the most useful. A pencil sharpener or knife for re-sharpening is essential.

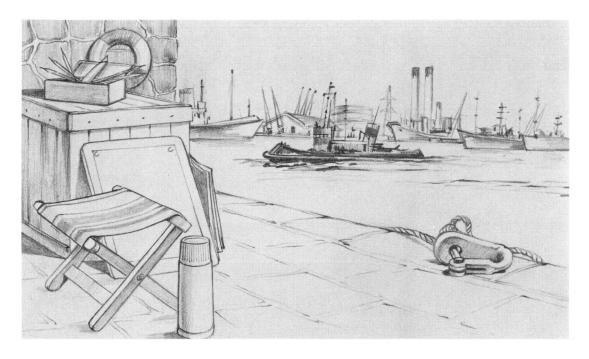

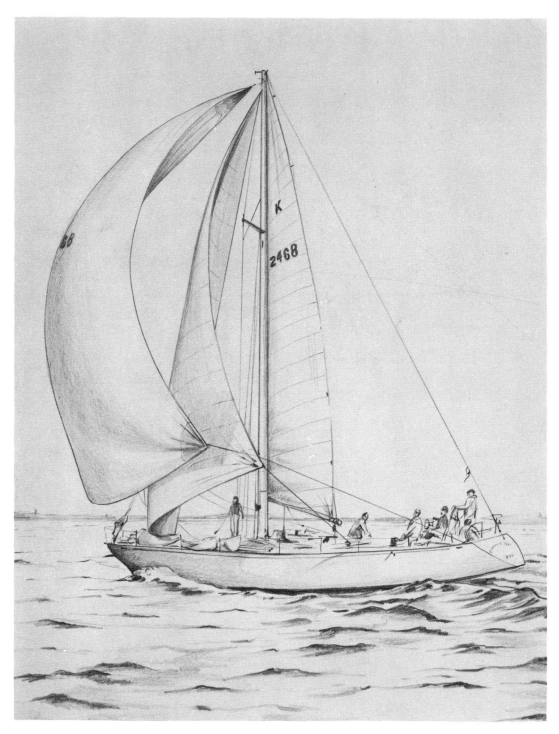

the fourth 'Morning Cloud'

Selection of Site

There are many places where we can sit and work without bothering other people, but there may be times when you wish to actually board a boat or enter a boatyard or wharf or even go into a field which has an adjacent river. It may then under these circumstances be necessary to ask permission to enter or use this property. Care must always be taken not to abuse these privileges otherwise owners may be antagonised and deny facilities to other artists in the future. Do not forget at all times to use common sense.

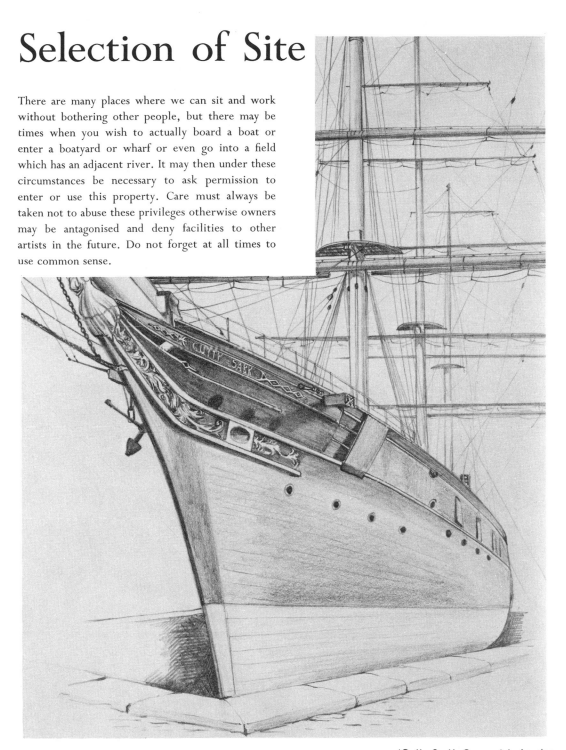

'Cutty Sark', Greenwich, London

Perception

'Fools rush in where angels fear to tread' is a universally known quotation, but when going out to draw I wonder how many of us sit down and put pencil to paper without first truly looking at the scene or object to be drawn. Fifteen minutes looking and really understanding our subject is never wasted before committing oneself to paper. It is absolutely essential that we consider exactly what it is we wish to draw and what it is we wish to leave out. Detailed considerations will be referred to in the ensuing pages and careful note of their content will save many a heartache and disappointment.

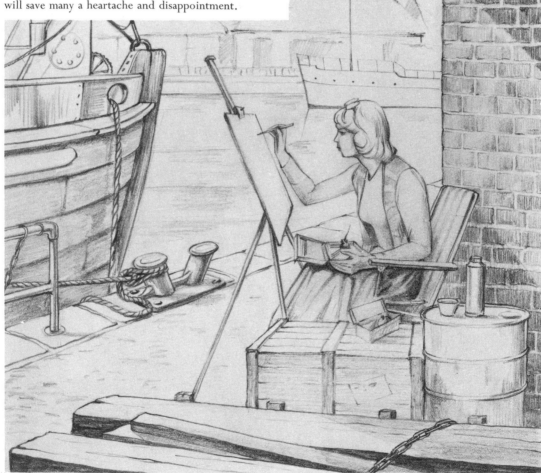

Approaches to Drawing

One of our greatest fears when beginning to draw in the great world outside is the exposure to public gaze and possible criticism. This is doubly worse when we are conscious of being true beginners and do not know how to tackle the task in hand.

There are several ways of combating this fear: one is to start by going out with a group of like-minded friends and this will make you feel less vulnerable; another is to practise drawing in the security of your own home and this can be done by selecting good photographs and translating them into pencil drawings. The study of photographs which hold water and boats still for you, allow plenty of time to practise techniques to simulate light, shade, reflec-

tions etc. will teach you to see more clearly when you eventually come to draw the real thing. Another method of study is to look carefully at other artists' work and their versions of this subject area and to study line by line how they have translated into pencil techniques.

After this kind of study and practice you will feel far more comfortable and confident about drawing the real thing outdoors. Make no mistake, there is, in the long run, no substitute for drawing from life. The very atmosphere of wind, smells, sound and movement somehow permeates our work and adds the necessary authenticity to our pictures.

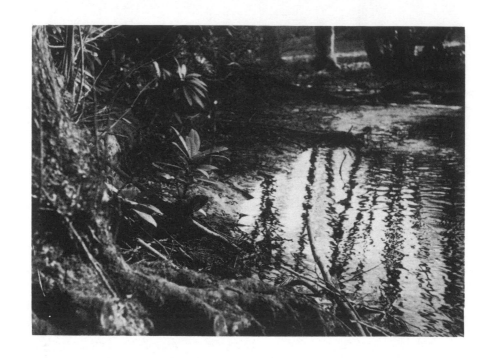

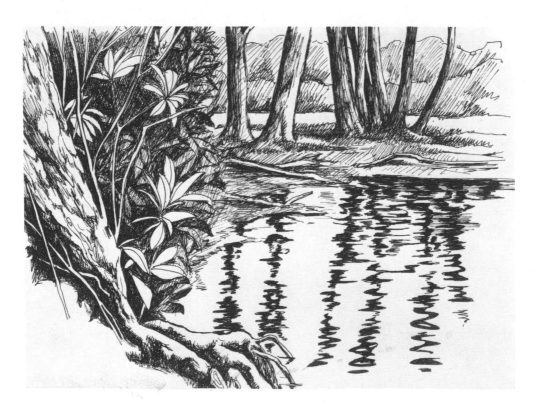

14

Where to Draw

Where to draw? The answer must be anywhere that boats or ships feature. In the following pages suggestions will be found but if particular subjects and venues are needed then a certain amount of investigation may be necessary. In researching this book I found most people I approached very helpful and not once was I refused permission to draw what I wanted. Be on the watch for the unlikely to happen. An example is the drawing on this page. It is a view from a friend's bedroom window in Southampton overlooking neighbouring roofs with the Canberra in the background. I thought it made an unusual picture with old tiles and chimneys as the main feature instead of the ship.

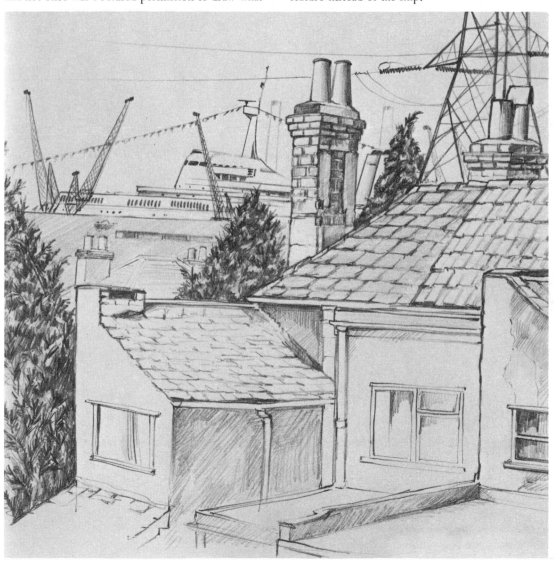

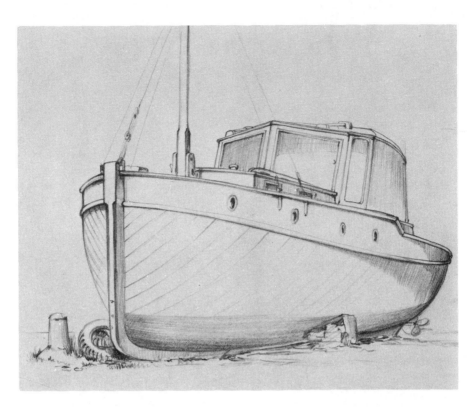

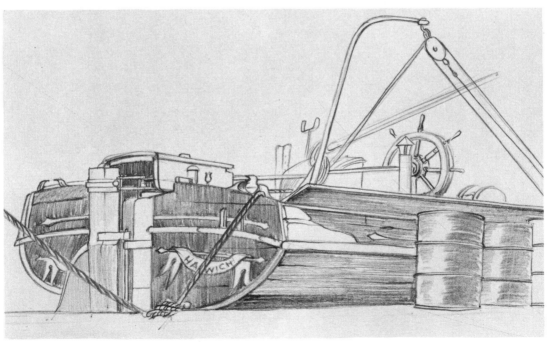

16

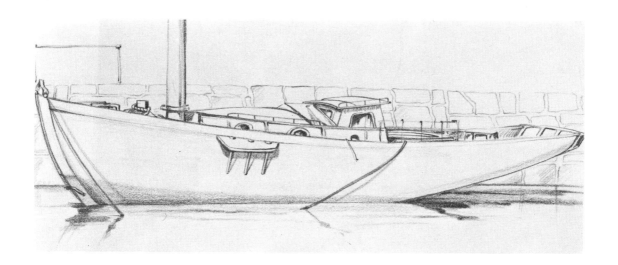

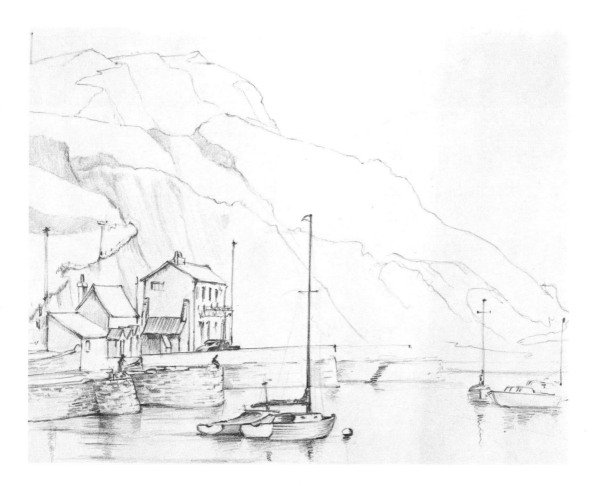

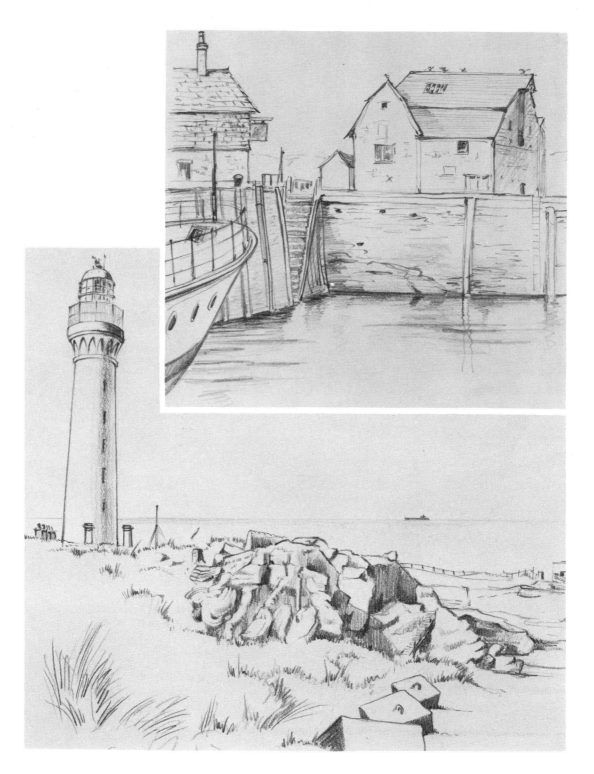

Rivers

If you are fortunate enough to live near a river or lake where craft are available, you will find a never-ending source of subjects to keep you busy. If not, it will be necessary to make special journeys to find your subjects. Whichever course you take, the resulting pleasure and achievement will make it all worthwhile. Many of us gravitate towards water of some kind during our holidays which give ample opportunities to study. It is well to keep a camera handy to capture all the sights around to help us practise when the holidays are over.

The types of boats we find on the river are many and include small rowing boats and sailing dinghies, motor boats and cruisers, yachts, speedboats and ocean-going liners. The illustrations cover many of these, both at moorings and moving. In most of these drawings there are ancillary objects which help to make up the backgrounds which are necessary to add authenticity to the drawings and eventually to make up complete pictures.

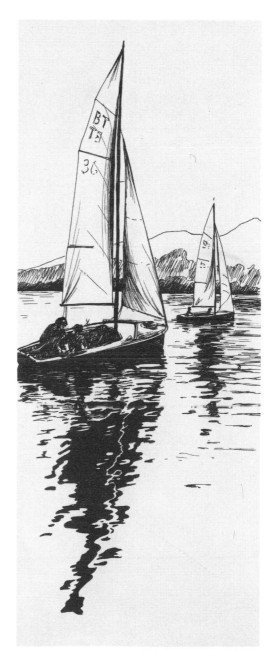

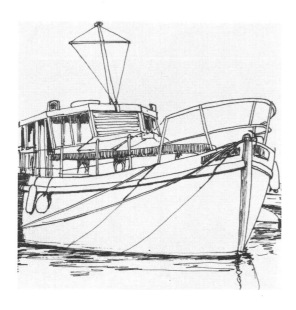

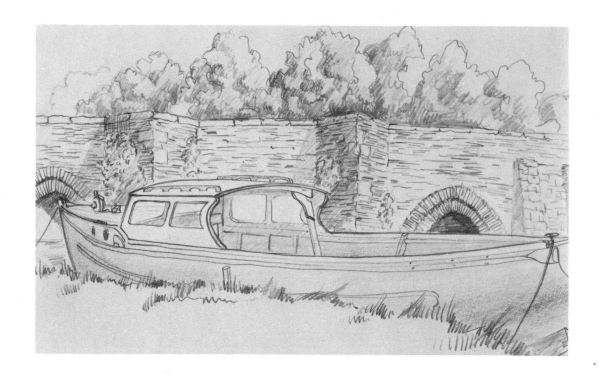

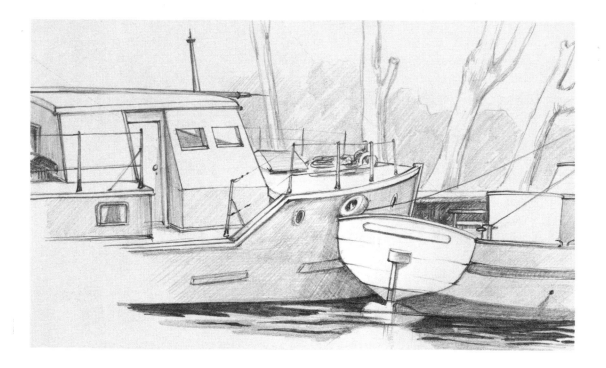

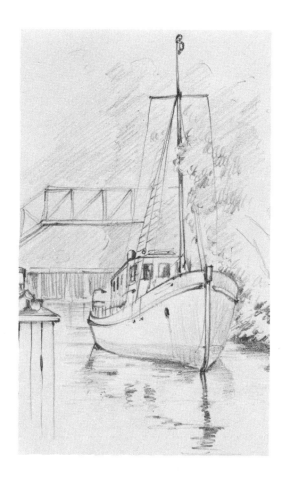

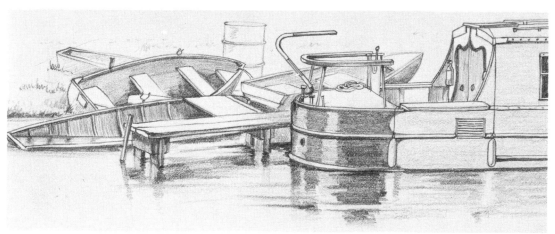

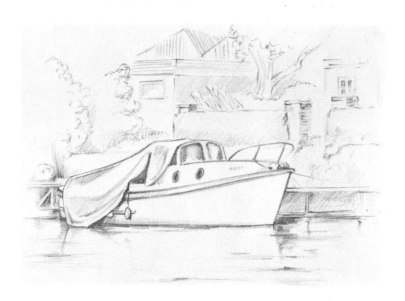

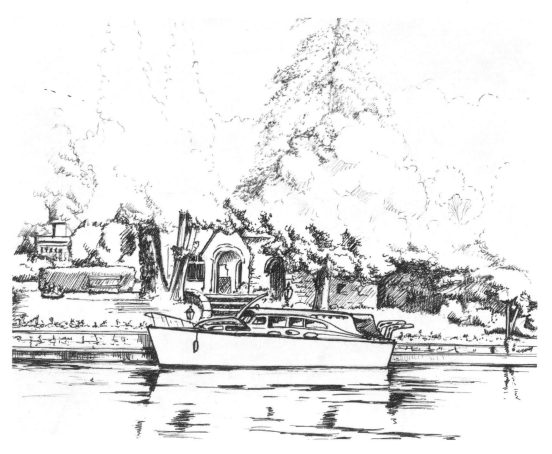

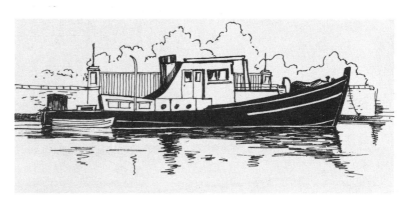

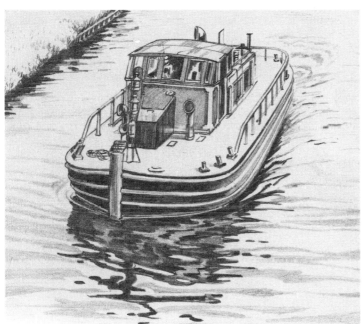

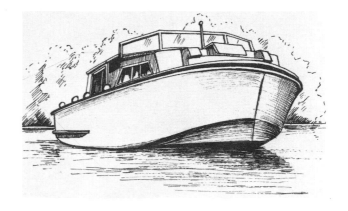

Boatyards

Boatyards are wonderful sources of interest. There seems to be so much back-up necessary to keep boats in repair and in good service, from repair yards and sheds, with all the attendant tools and tackle, to jetties, bollards, piers, engines, trailers . . . and a thousand and one other items which are fascinating to draw and add so much to your pictures.

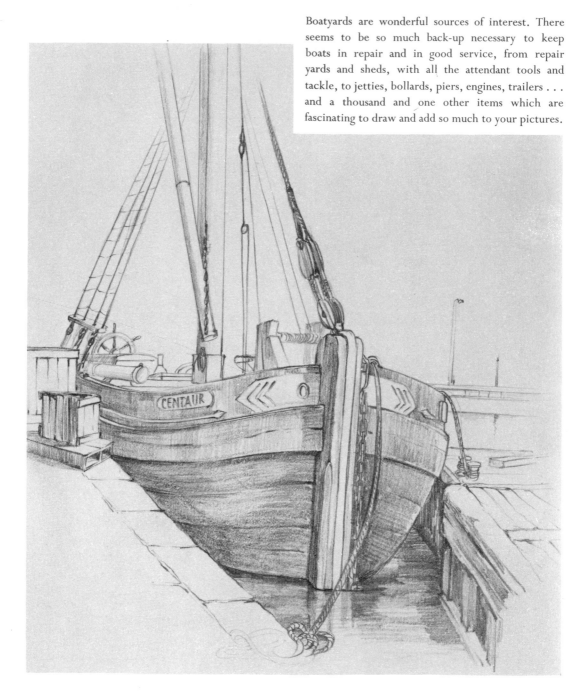

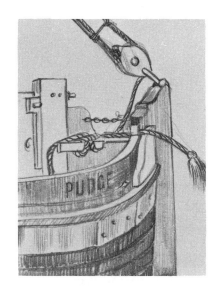

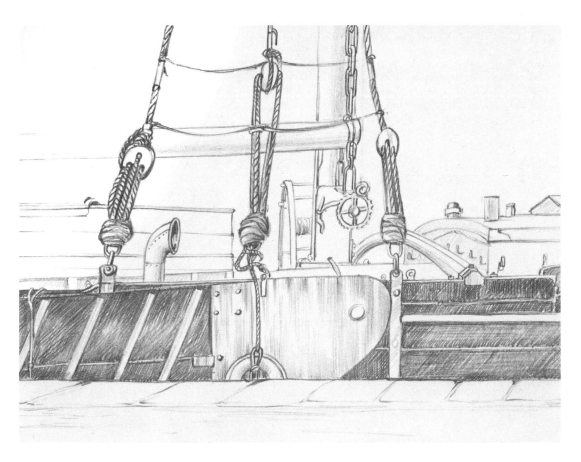

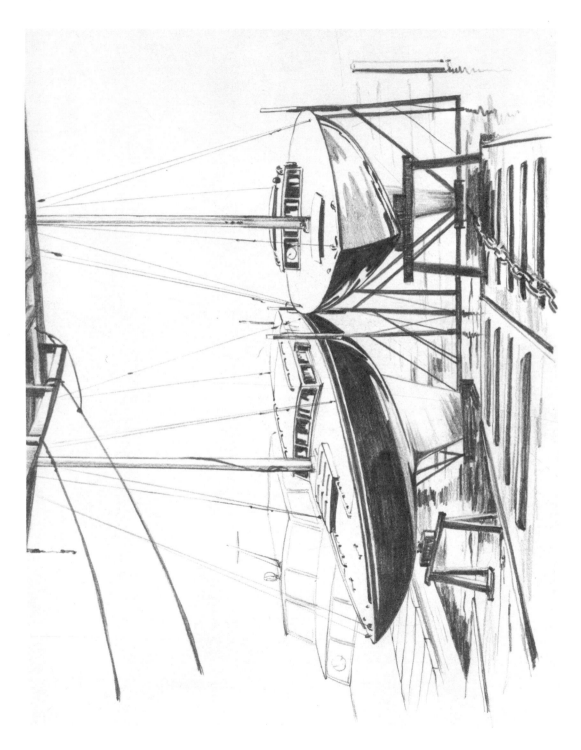

26

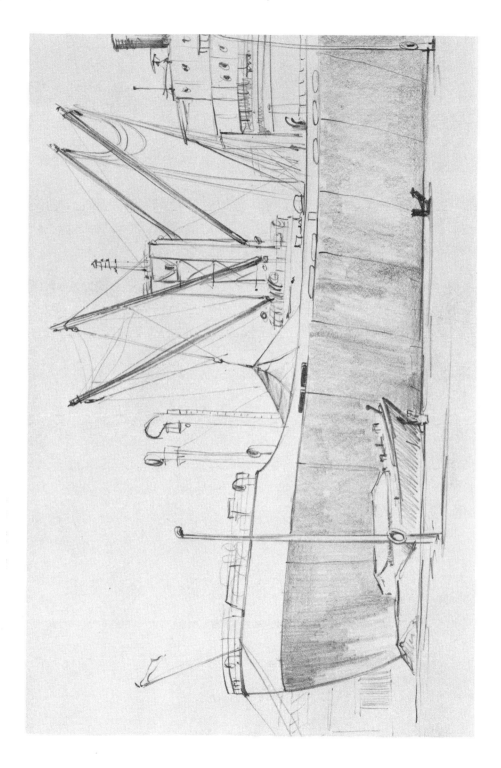

Docks

Docks again have much to keep one busy with a never ending supply of equipment. There is a grand pattern in most docks made by cranes, which is always exciting, plus trolleys, bales and crates of goods, passenger gangways and people, fishing gear, nets, creels – the list is never ending in its variety and complexity.

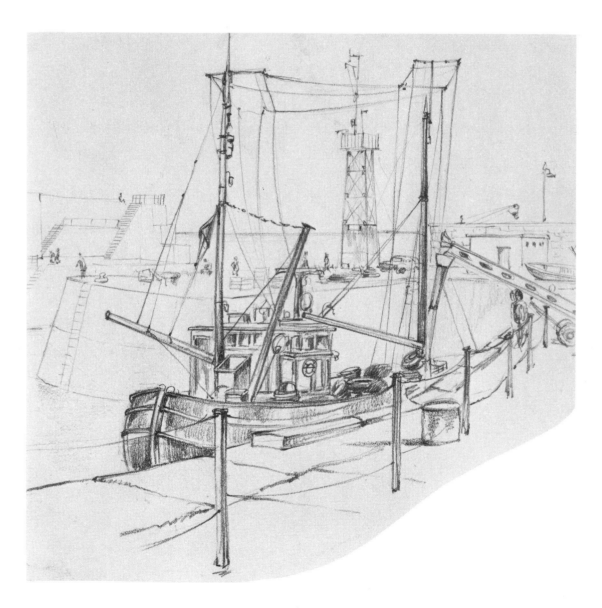

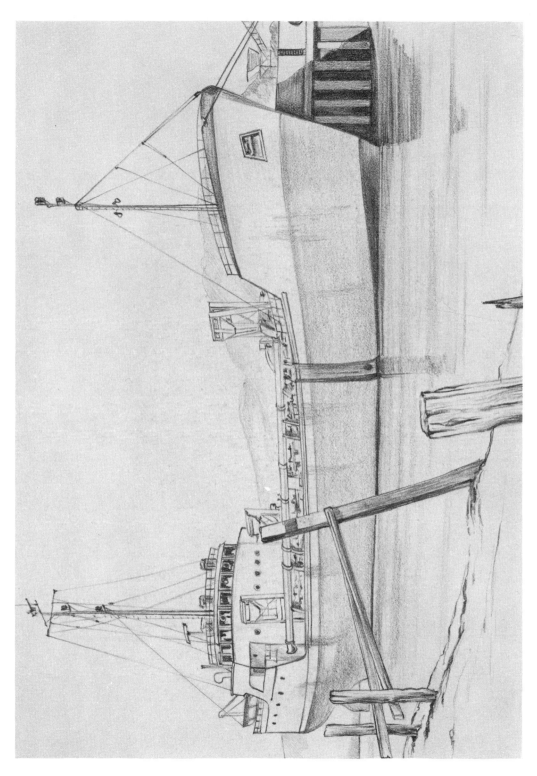

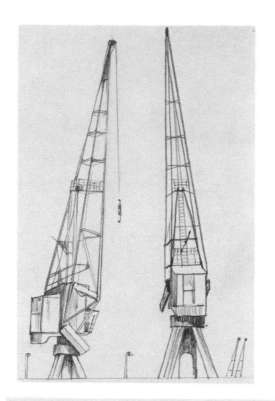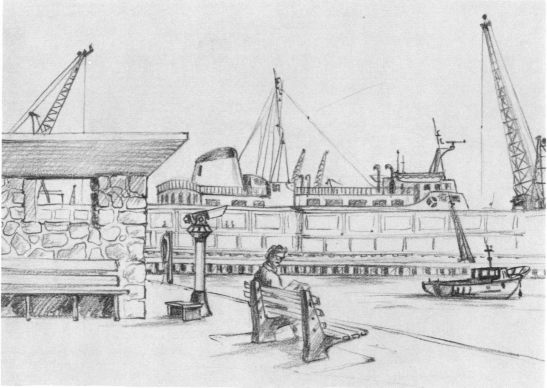

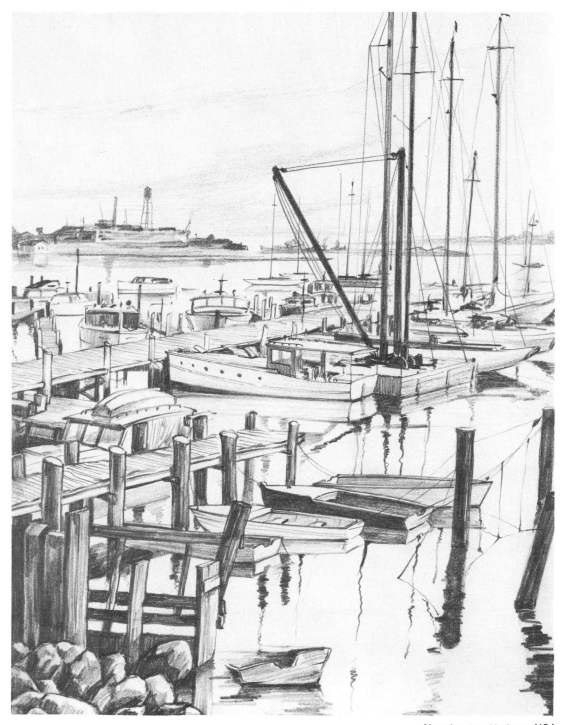

New London Harbour, USA

WATER AND MOVEMENT
Ponds and Lakes

Water seems to be a living element as it is continually moving or reflecting movement. Ponds and lakes do not generally have the motion of rivers and seas because they are usually captive bodies of water but, of course, the surface can be moved by the wind. When drawing water it is essential to find an object to be reflected (see the first example in this section) and to bear in mind the examples of reflections (page 49).

In the example on this page it will be noted that the church steeple reflection is broken by areas of white which indicates underwater currents in this lake which moves the water in a different direction and allows the water to catch the light.

Anything can be drawn as a reflection as long as the bulk of the lines or shadows are horizontal in character. By its very nature water finds its own flat level and even if the picture of water appears to be going uphill, the lines must always be horizontal, otherwise what you draw will be a road or track and not a flat area of water.

The pen and ink drawing on page 36 is an example of a different technique and approach to drawing water. This drawing shows how the pattern of water and pond weed is used in a decorative fashion and not taken too literally. Note, however, even in this drawing where there is not an over-emphasis on realism, the water lines are still basically horizontal thereby maintaining the character of water.

Rivers, like all concentrations of water, have many variations of size, movement and individual characteristics which depend on differing factors. It would be ideal to have a film stopped every few frames to see exactly how water makes its own peculiar patterns.

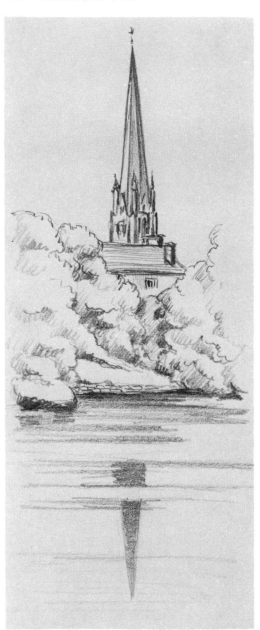

33

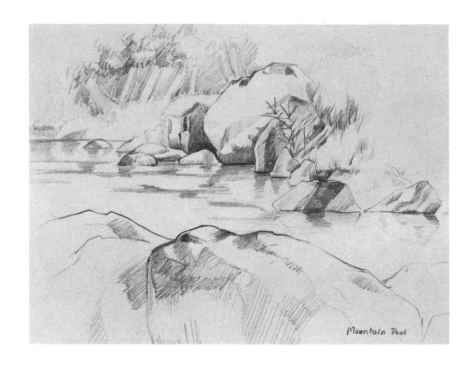

Mountain Pool

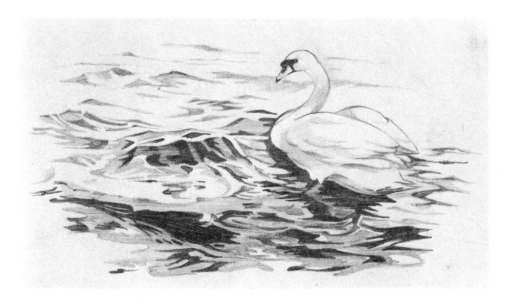

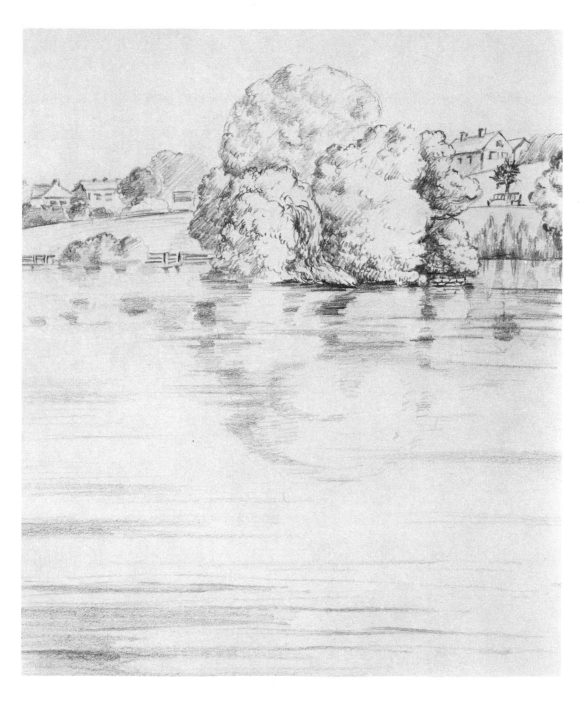

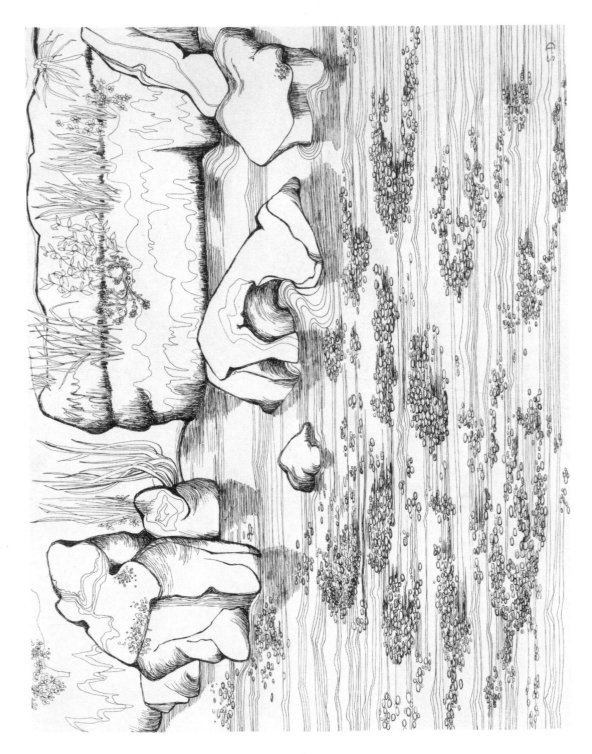

Rivers

With water movement, a lot can be learned by looking at still photographs and also by careful watching of one small patch of water to observe the regularity of the pattern it makes. There are many factors governing movement but there is bound to be repetition in studying them because only a few simple rules apply in drawing water movement.

The illustrations will help to understand some of the details involved. The study on this page of a simple one-stage waterfall will reveal that the main body of the river appears still and calm up to the edge of the water drop. Although this was drawn during a flood the only appearance of rushing water is when it actually curves over into the lower level creating a turbulence. This is achieved by drawing the higher level with firm, clearly defined reflections, also clear light and shade on the heavy weight of water dropping, then changing the technique to soft, frothy light and shade in patterns. Contrasting

waterfall patterns will be described on page 40.

Stillness of the water surface of a slow moving river is comparatively easy to depict; it basically depends on lines and shadows of reflections being drawn horizontally and the more light and shade there is the better the simulation of a glass-like reflective surface (page 19).

Creating further illusions of reflectiveness can be achieved by adding details well associated with rivers, i.e. bridges, either simple or complex. Page 39 (top): this is a simple bridge structure over the river Wey in Surrey, plus a few upturned boats for good measure. The water is almost non-existent but there is no doubt that this is a river scene. Below, on the other hand, there is the river Thames at Kingston Bridge, again in Surrey, where a lot of water is described and many horizontally drawn reflections show the stillness of the water. The bridge drawn faintly gives the illusion of distance.

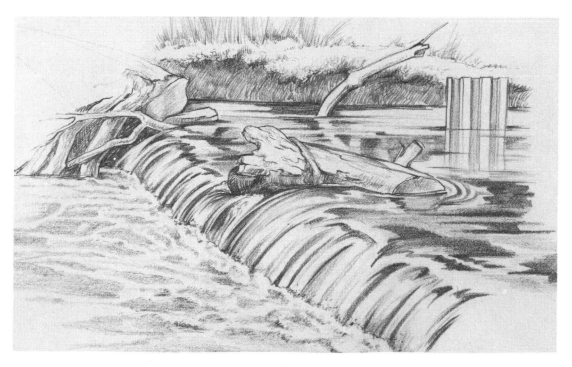

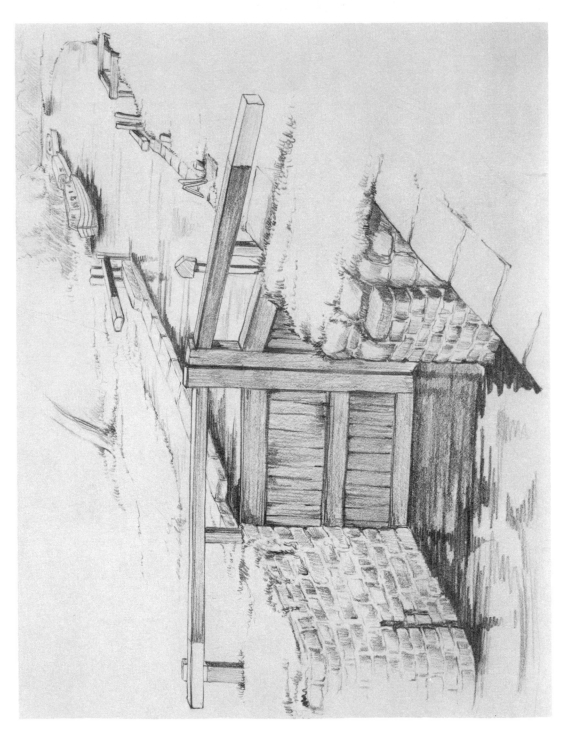

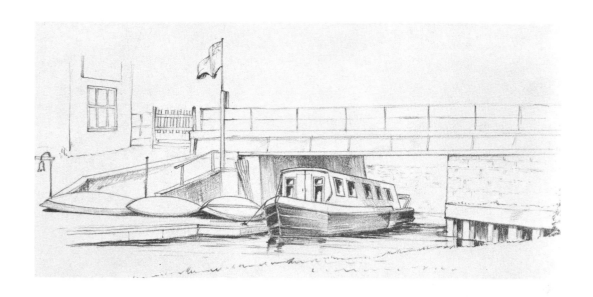

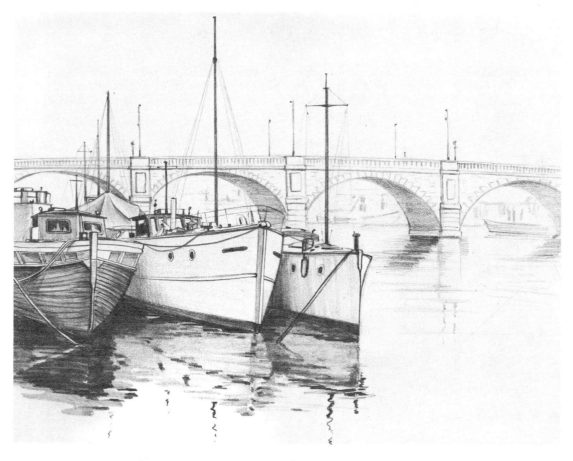

Waterfalls

Waterfalls have a magic of their own. I would only recommend giants such as Niagara or Victoria Falls to those who have a fair degree of practice, but study of complex small falls can give all the details needed and are easier to do at close range. The drawings

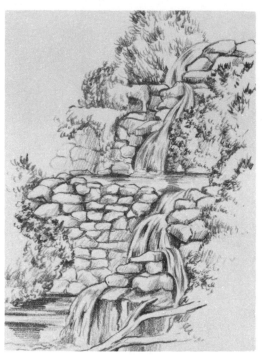

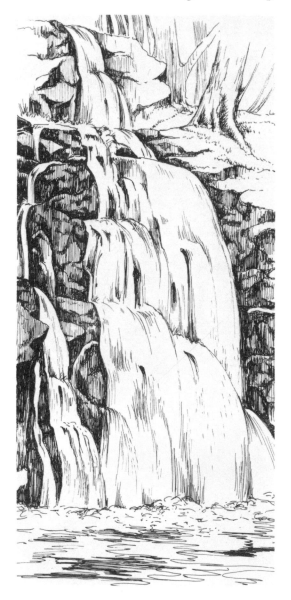

shown here are of the same waterfall from different angles, one in winter in spate, the other during a hot summer.

It will be noticed that the surrounding vegetation is more evident in the summer study and non-existent in the winter one. When there is an abundance of water a lot of details are smoothed out and water literally appears as a sheet and can be drawn as such. The force of falling water can also be described by the bubbling movement at the base of the waterfall as the water crashes into the pool below.

Interest can always be found in the immediate surroundings such as rocks, trees, roots, bushes, etc., and these add to the authenticity of the study. Drawing the water on its own may not give the same impression.

Page 41 shows two views of a river, one with an eye level fairly high so that a large body of water may be seen. This study was to show an interesting tree root over a flooding river (note the turbulent water). The other study is with a low eye level where hardly any water is showing but what there is appears to be rushing under the bridge which is the dominant feature of the drawing.

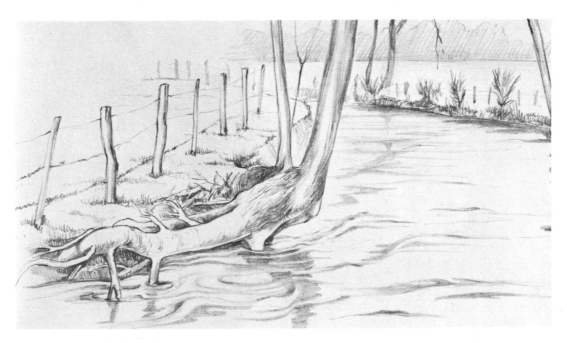

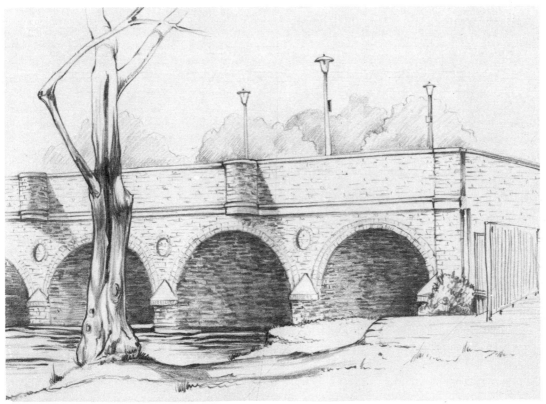

41

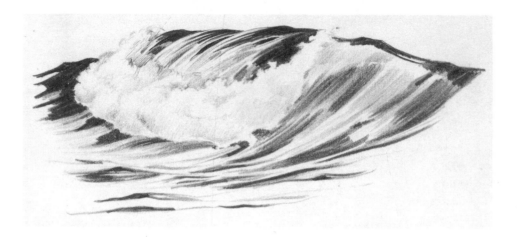

Oceans

A great body of water is ever changing, and this depends on so many different factors. Wind and tide have an enormous effect on the surface we see, the aspect with which we are primarily concerned. It is not necessary to know too much about why the sea acts in a certain way but to be conscious of the pattern of movement which is caused by certain conditions.

A calm sea can be a vast reflective surface with only minimal movement caused by the tides (fig. 1), whereas a high wind can generate troughs and the weight of water moving to and fro creates great waves, which in turn collapse under their own weight causing white tops and spume carried by the wind (fig. 2).

When watching ships in such heavy seas it can be seen that a large part of the vessel is often obscured by the troughs and if drawn this adds to the artistic impression of the power of the sea (fig. 3).

Scale plays an important role in creating the impression of large or small waves. Fig. 4 shows how small the waves appear because the boat is drawn so large by comparison and fig. 5 depicts the opposite effect and gains the feeling that the boat is puny and at the mercy of giant elements.

When the sea is seen from the shoreline, again wind and tides play an important part. There are occasions when the sea is as calm as the proverbial mill pond and others where the breakers and waves are very powerful. The lines of waves are also affected by anything in their path such as rocks, groins, jetties, etc.

A breaker is created by a body of water being pushed in one direction until it loses its momentum and on its return meets another wave coming in the opposite direction (fig. 6). This produces the effect of piling up the water until it collapses under its own weight and makes the characteristic wave shape.

When drawing these waves the direction of the prevailing light has to be considered as this casts shadows and reflections which are essential for a successful interpretation of the scene on paper.

Clouds and sky conditions also have an effect on the surface of the water. This aspect is dealt with in a later chapter as it is an additional element in picture making.

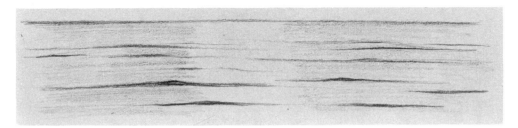

Fig. 1

Fig. 2

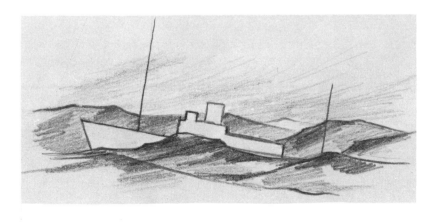

Fig. 3

43

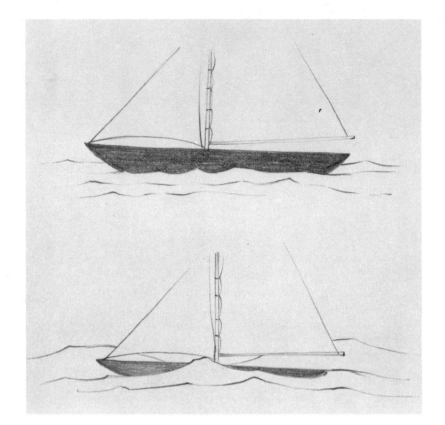
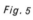

Fig. 4

Fig. 5

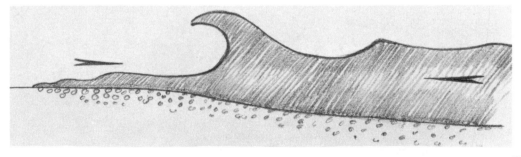

Fig. 6

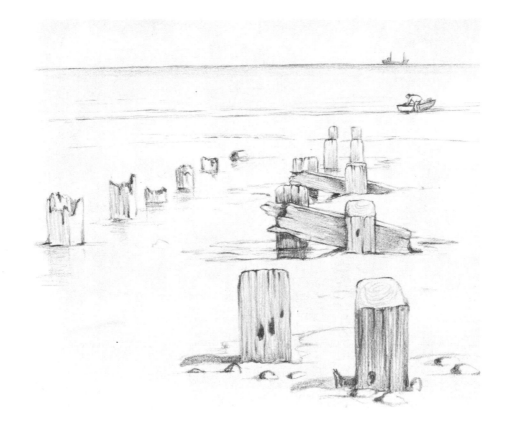

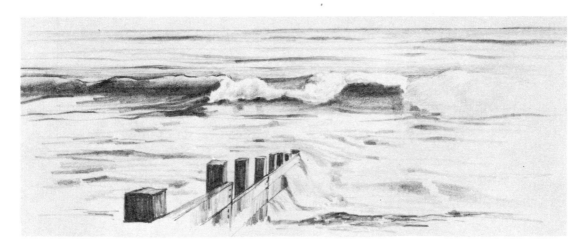

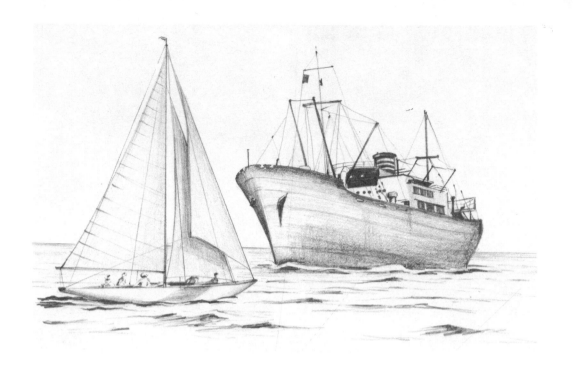

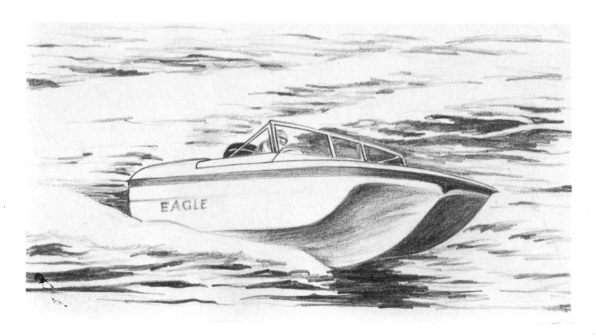

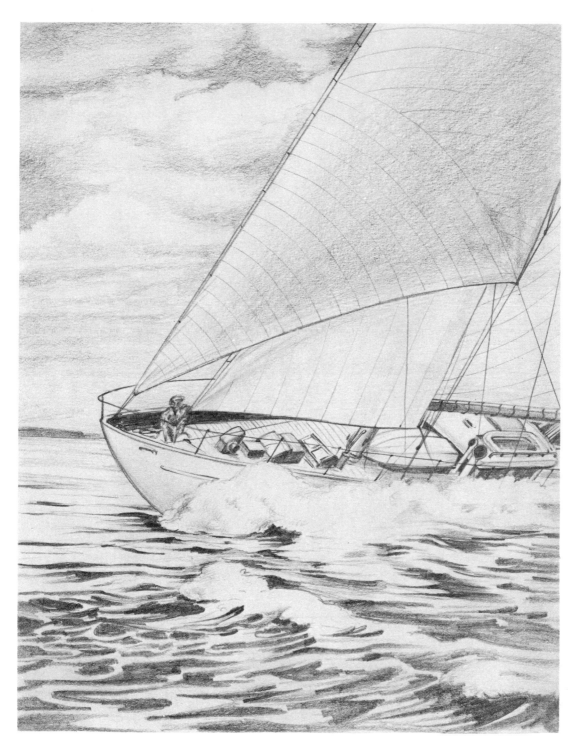

Reflections

A reflection is a mirror image of an object which is near a shiny surface, in this case water. The clarity of the image depends largely upon the colour of the water. As a mirror depends upon its dark silvered· backing to make it reflective, so water requires a dark, dense appearance to bounce the image off its surface.

The illustrations may help in the understanding of the principles of reflections as far as the artist is concerned. A simple demonstration can be staged in your own home by placing a mirror horizontally on a table and then placing an object upon it at its far end, page 49, fig. I. Note how clear the image becomes and that it is an exact facsimile except that it is upside down. This example can be likened to absolutely clear still water (fig. II).

Fig. III now illustrates how an object becomes a distorted mirror image when the surface of the water is slightly agitated. Then continuing with further disturbance of the water the image is almost totally destroyed and becomes unrecognisable (fig. IV) but still gives the water a reflective look.

Perspective of reflections on water surfaces plays an important role in making our representations look authentic. To put this concept into simple terms, the further an object is from the eye the clearer the reflection on a disturbed water surface, whereas the nearer the object to the eye the reflected image becomes more fragmented on the broken water surface.

In fig. V it will be noted that the wavelets in the distance are closer together; therefore the reflection of the image which touches the top of each wavelet are also closer together and show a more solid reflection. As the wavelets in the middle distance and foreground are nearer to the eye one can see troughs left between the wave crests becoming larger. These non-reflecting areas break up the image between the reflecting wave tops and fragment the image until it disappears and becomes unrecognisable.

This very fragmentation is one of the aids in making the water look wet and objects upon it appear to move.

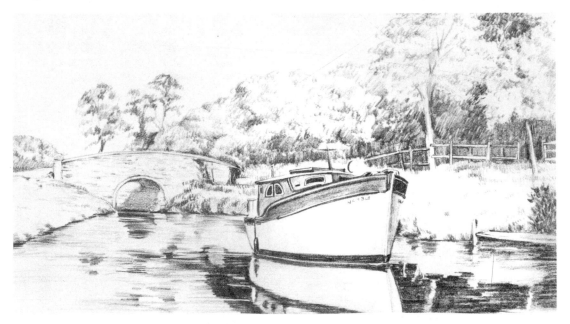

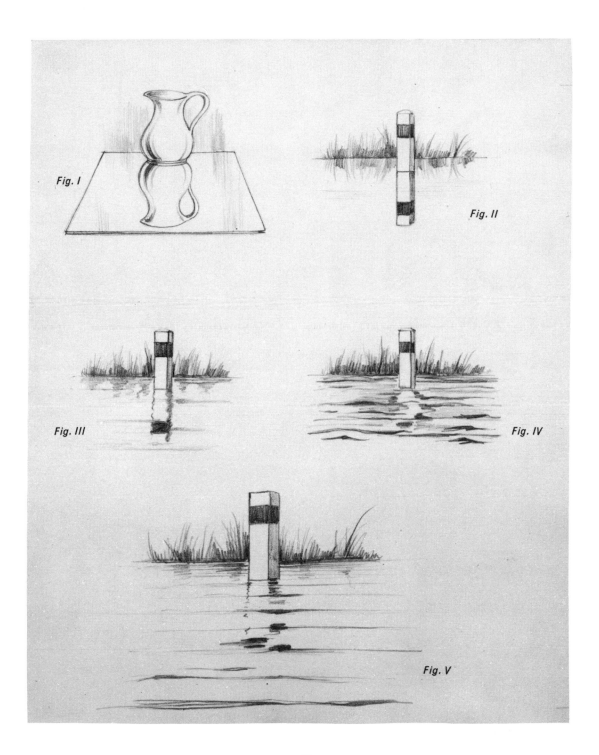

Fig. I

Fig. II

Fig. III

Fig. IV

Fig. V

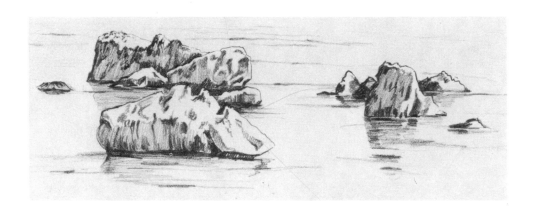

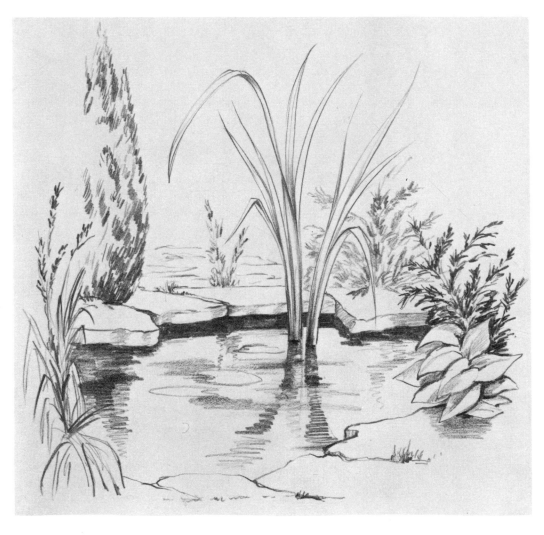

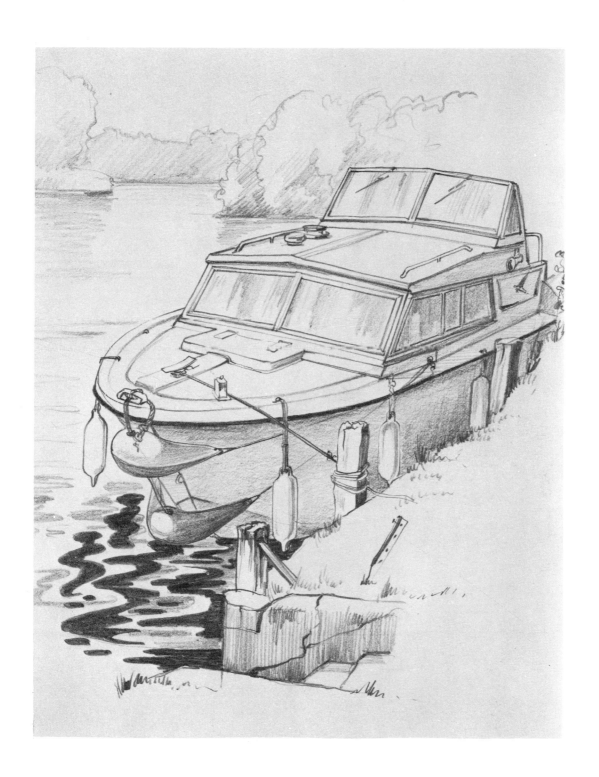

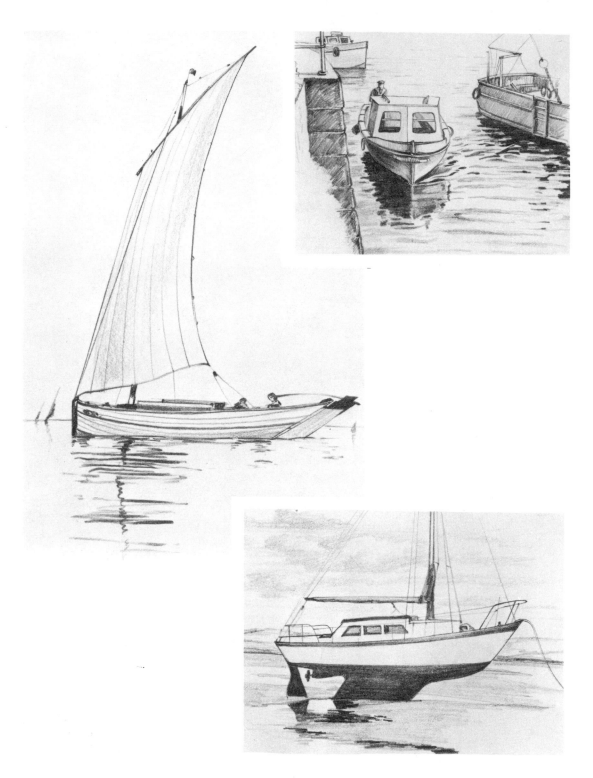

Sky and Clouds

Considerable dramatic effects can be achieved by the use of clouds and dark skies in your pictures. The obvious example is a black glowering sky full of rain clouds in a storm at sea; the character and atmosphere of the picture is immediately created.

The other use to which clouds can be put is as an object to be reflected, which has been mentioned before. The object does not necessarily have to be solid, the dark areas of clouds are quite sufficient to give a reflective substance on water or waves. The examples of the use of clouds in this section will give an idea of the completeness of a picture and the creation of an atmosphere.

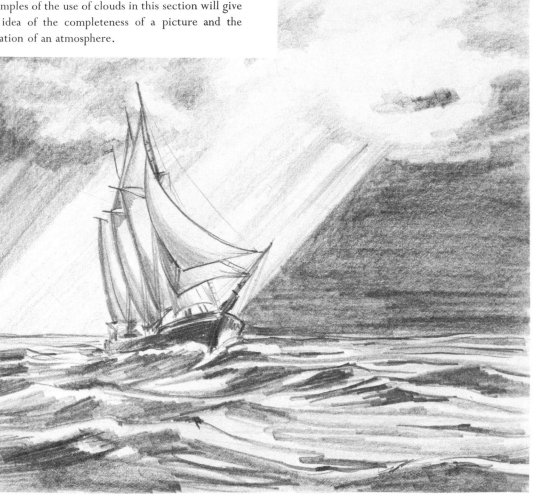

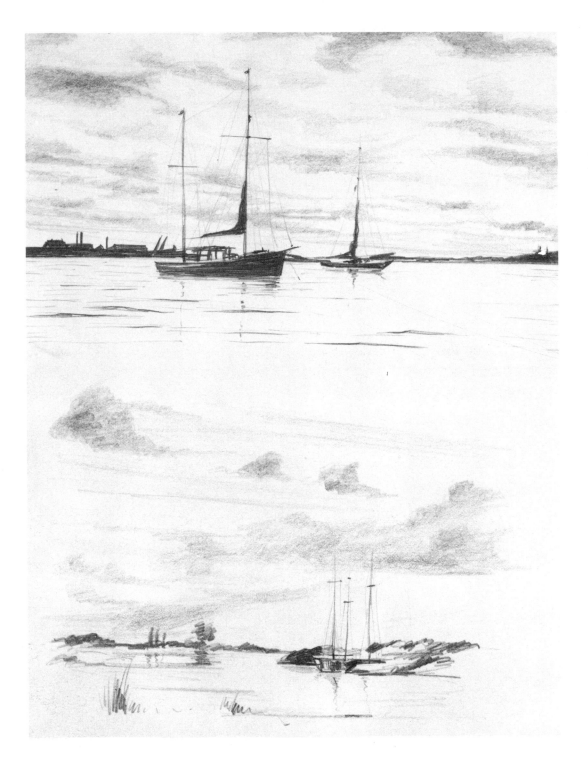

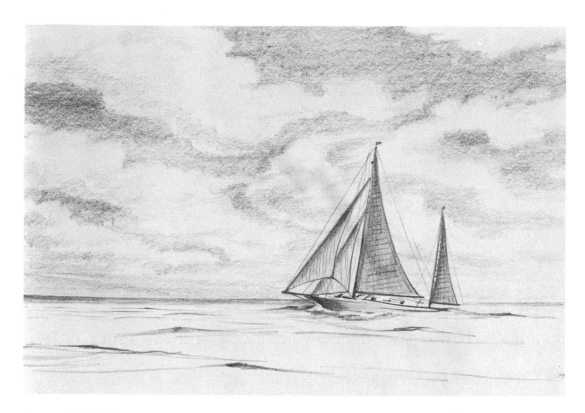

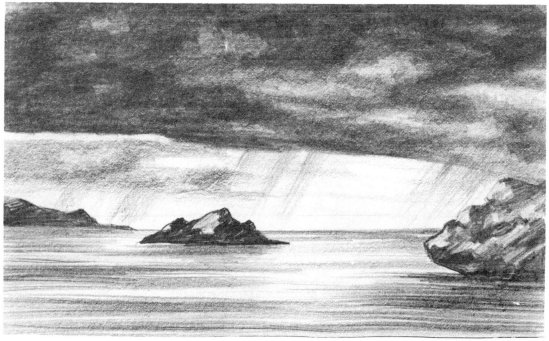

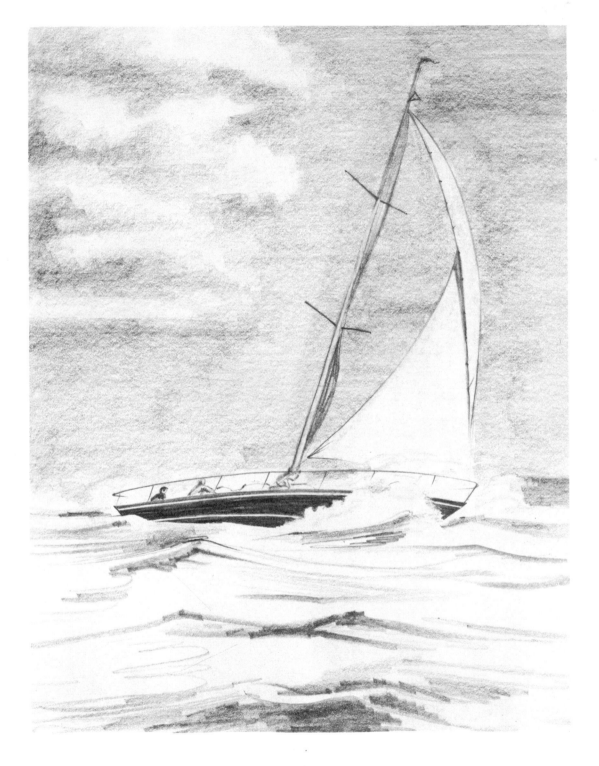

Light and Shade

The effect of light and shade is very important to consider as it can make or break a drawing. It is one of the components in drawing to recognise, as valuable as reflections, perspective and composition in getting the best out of your pictures, as well as adding a certain drama and authenticity. The illustration on this page of the rowing boat in absolutely still water shows how a hot summer's day can be portrayed by flooding the whole picture in white light; only the slightest hint of dark areas are used. On the other hand a similar effect can be achieved by the use of very hard shadows (pages 58, 60), the hard light being illustrated by the use of contrast.

The illustration on page 59 uses a general light which does not emphasise too much in the way of

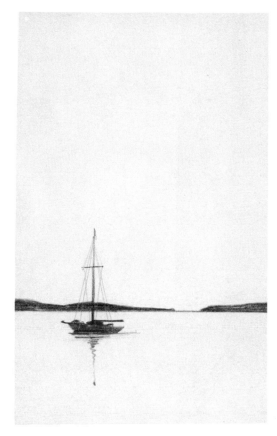

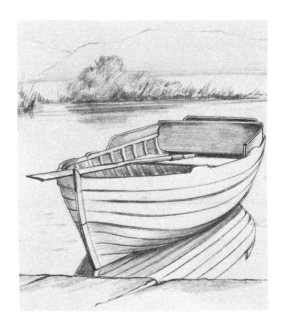

shadows and thereby creates the sort of day we know so well with an all-over soft light, the shadows on the water being used to differentiate between the still water and the turbulent cascade.

The two illustrations on page 61 show the different effects which can be created by the use of light or dark sky. The top picture is bright by virtue of drawing no sky at all and making the shadows on the waves quite hard and not too frequent, giving the impression of the sea being flooded by hard, bright light. The second picture uses the dark clouded sky and more shadows on the sea which gives the effect of an impending storm. The use of bigger and more turbulent waves for the stormy effect helps to create this impression.

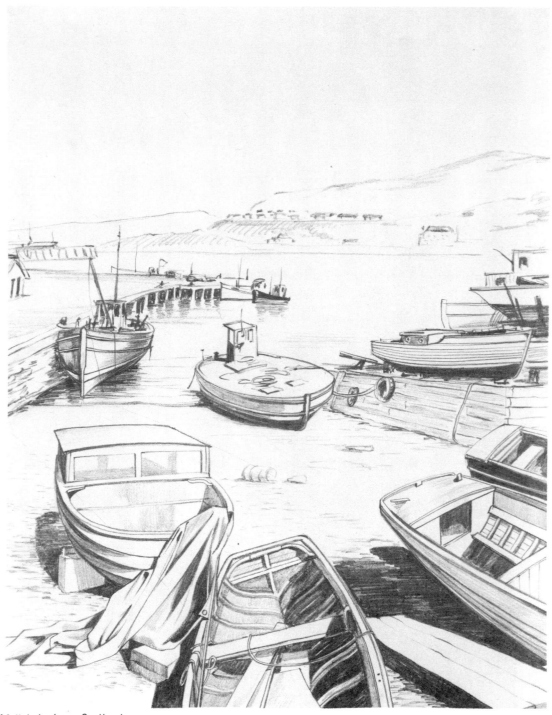

Mallaig harbour, Scotland

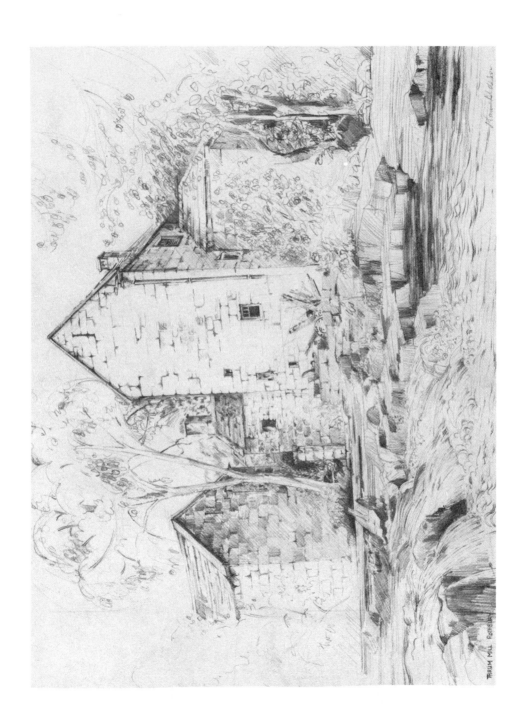

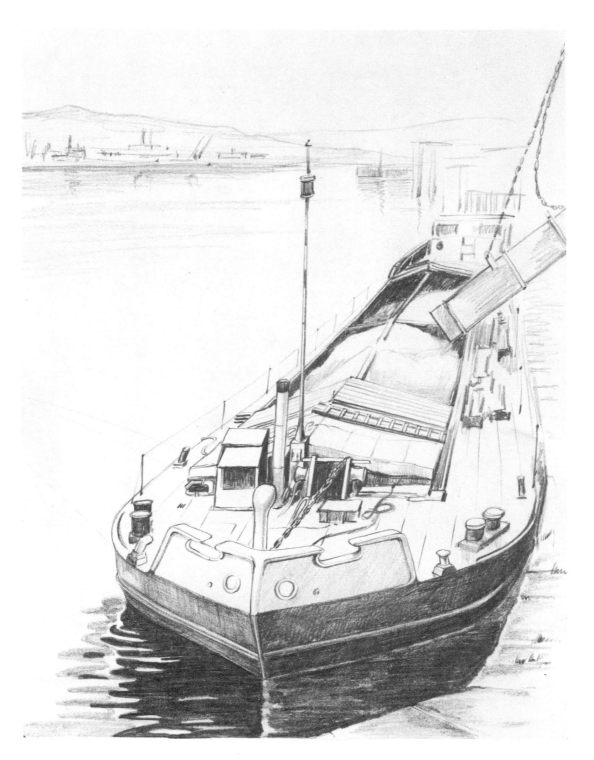

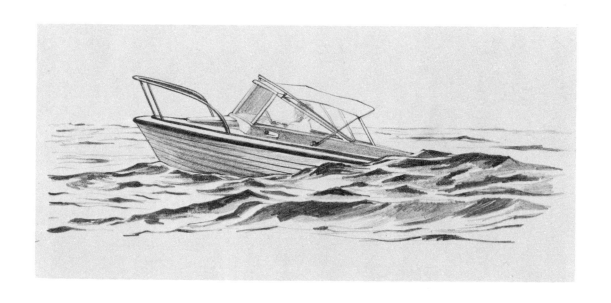

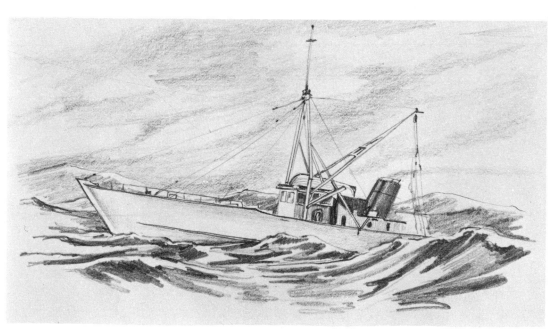

Prawn trawler

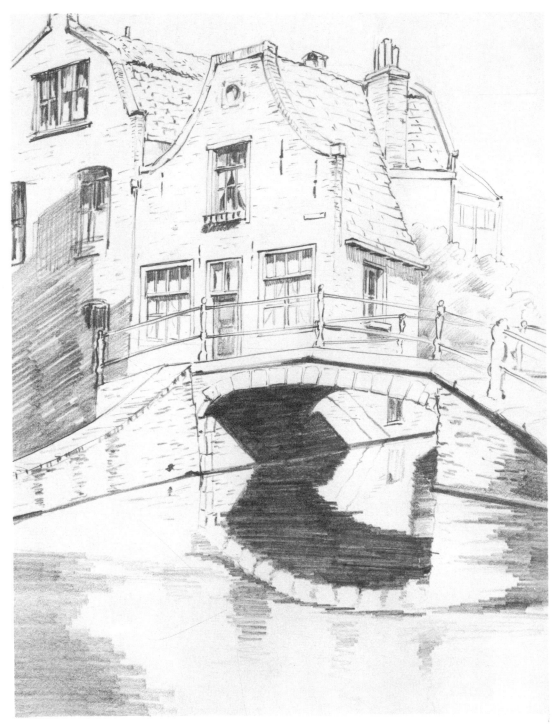

Amsterdam

Composition

Making a successful picture seems to some people to be difficult. Some aspiring artists find it easy enough to draw their chosen subjects but wonder about the arrangement on the page to achieve the best effect. The following diagrams will help to gain the best from the drawings and will show a variety of approaches.

Perspective plays an important role in picture making and it must be remembered that we 'see' perspective all the time but we must learn to recognise it and be able to interpret what we see in three dimensions and convert this 'seeing' into two-dimensional terms.

The first aspect to consider is where to place the horizon line in your picture. The higher the horizon line the higher your eye is on the subject (fig. I) and the smaller the objects will appear. Conversely the lower your horizon line the lower your eye in relation to the subject and the bigger and grander will your subjects appear (fig. II).

The next thing to consider is where to place the main part of the subject in the picture and the next few diagrams on page 65 will help you in these arrangements.

From fig. A, it will be noticed that the ship is placed too close to the edge of the picture facing the direction of its progress and therefore looks as if it is about to sail out of the picture. This is most uncomfortable; it is better to leave a space in front of the ship as shown in fig. B.

The position of the boat in fig. C is too central and somewhat boring. It is preferable to have the boat off centre as in fig. D which also gives an opportunity to lessen the area covered by an uninteresting shed on the left and enhances the appearance of the bridge in the background.

The surfing diagram, fig. E, shows a combination of the previous faults. The figure of the surfer is centralised and the direction of the waves is tending to take the eye shooting out of the picture. By placing the figure off centre and using the waves and swirling water, the eye is taken around the picture continually in a circular motion.

The basic perspective of objects is illustrated on page 66. In fig. I, with the high horizon line, you are looking down on the ship and therefore select two vanishing points on this line and then construct an oblong box with the lines vanishing to these two points. Within this box the ship can be drawn. Even the most complicated structure can be drawn remembering that all parallel lines must disappear to the appropriate vanishing points.

Fig. II has a lower horizon line, but the box construction is still applied with two vanishing points. It will be noted that the position of the low horizon line makes the ship appear bigger. To illustrate this concept of scale one has only to imagine being up on a high cliff looking down on the sea where the ships will appear small and toy-like, or, on the other hand, swimming in the sea with eyes on a level with the horizon, where a ship coming towards you would look huge and tower above you.

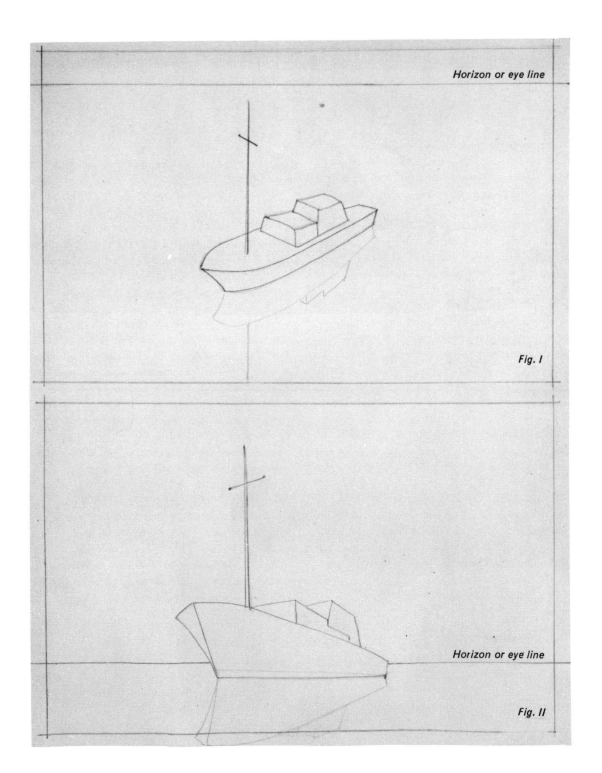

Horizon or eye line

Fig. I

Horizon or eye line

Fig. II

64

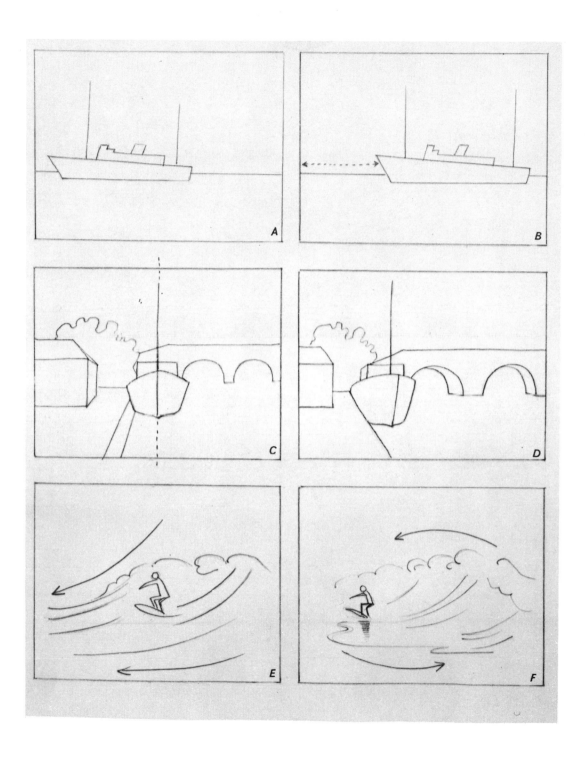

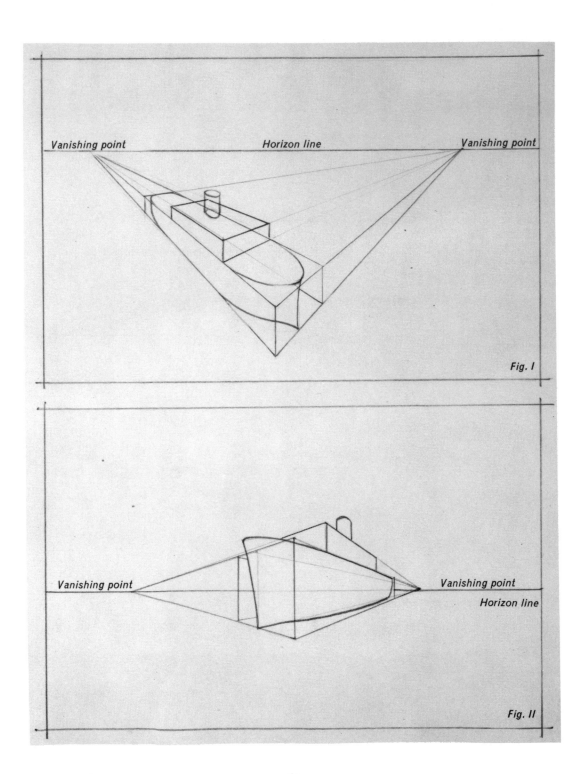

Fig. I

Fig. II

66

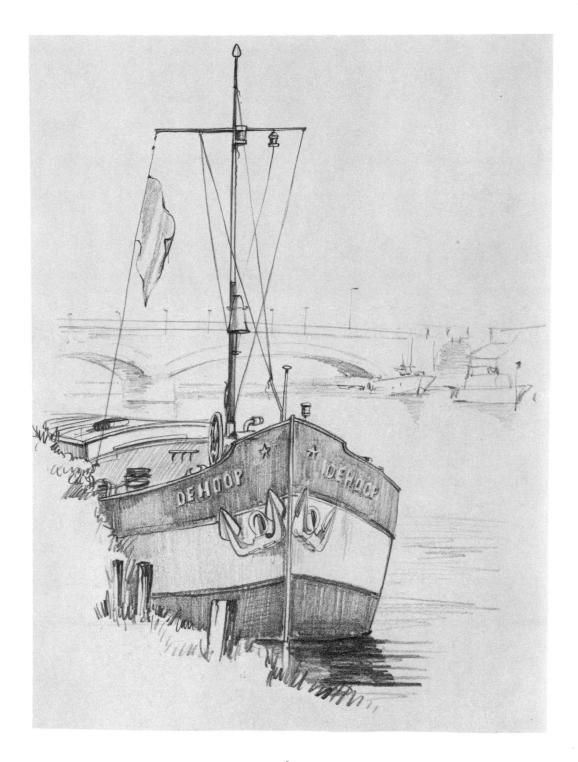

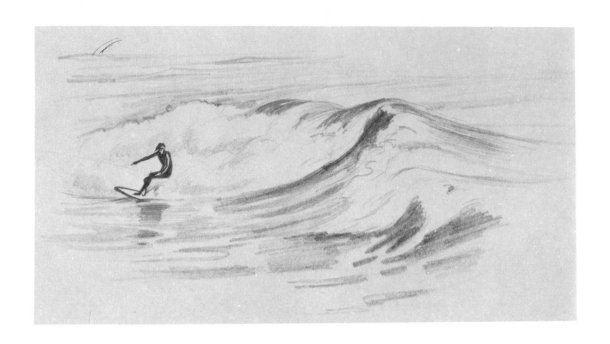

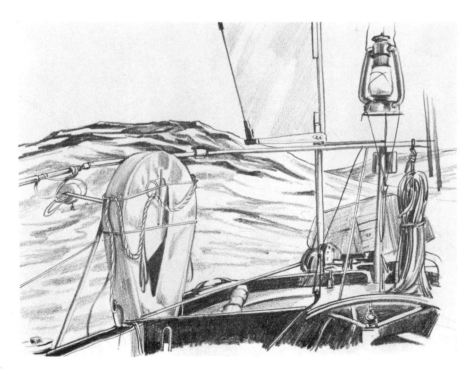

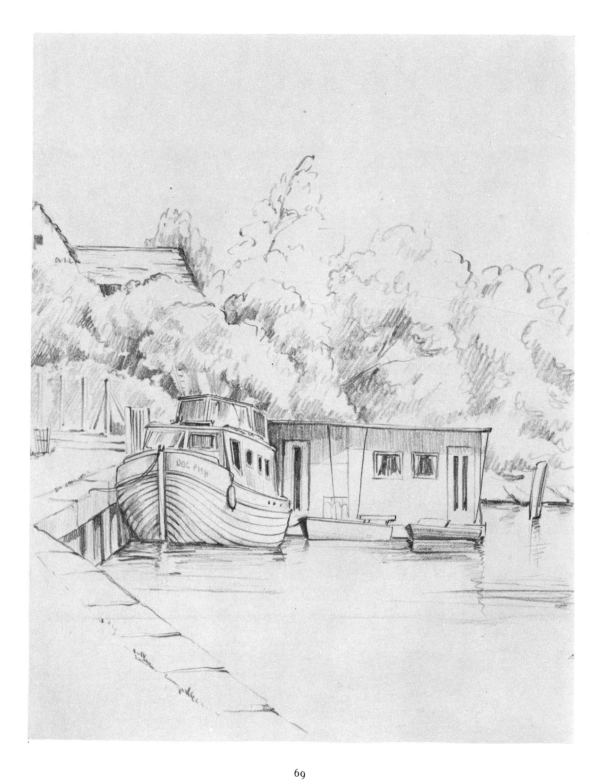

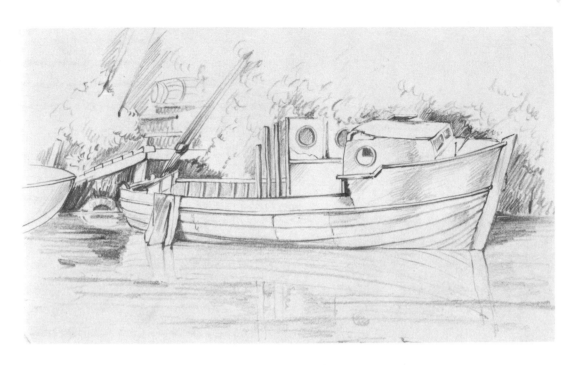

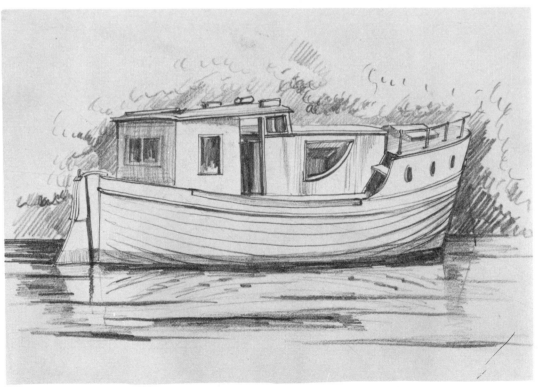

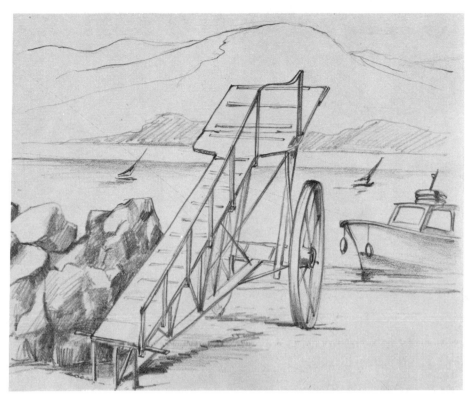

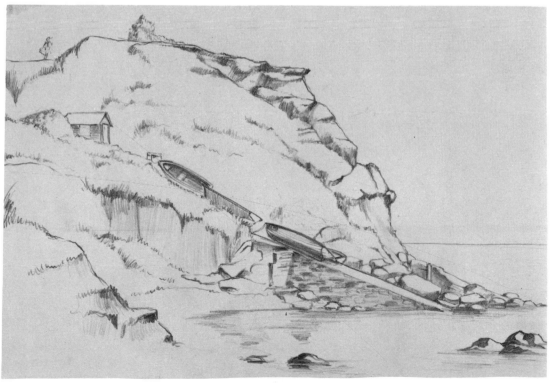

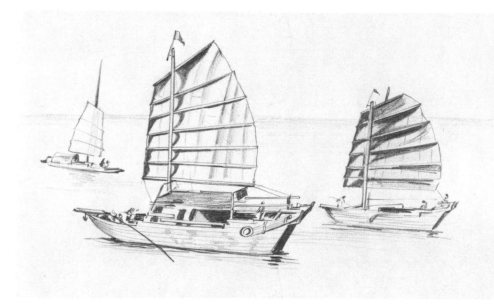

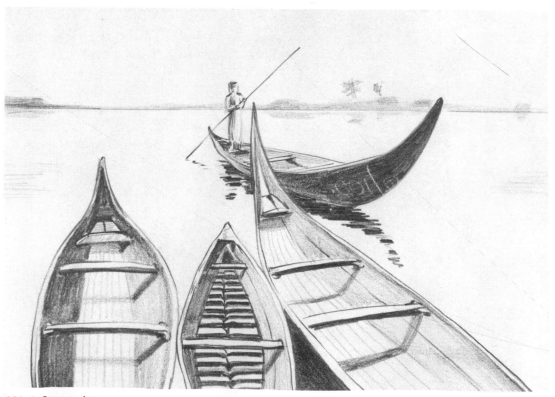

Marsh Canoes, Iraq

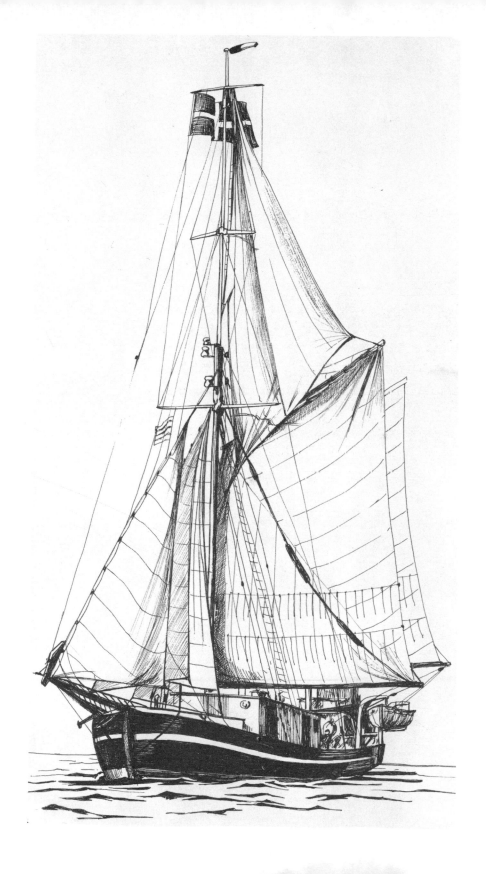

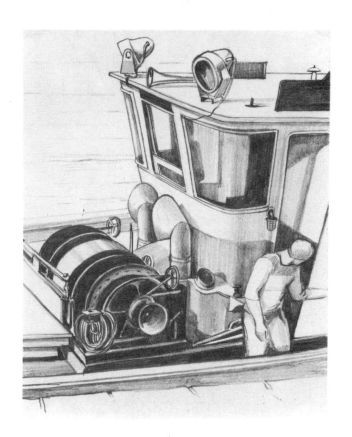

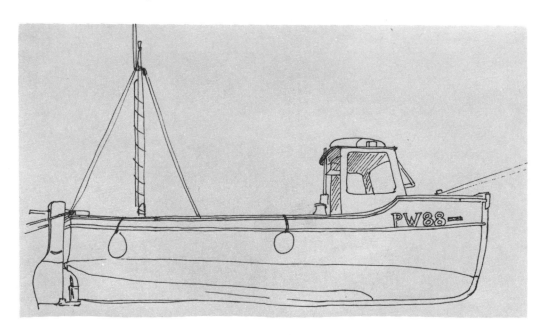

74

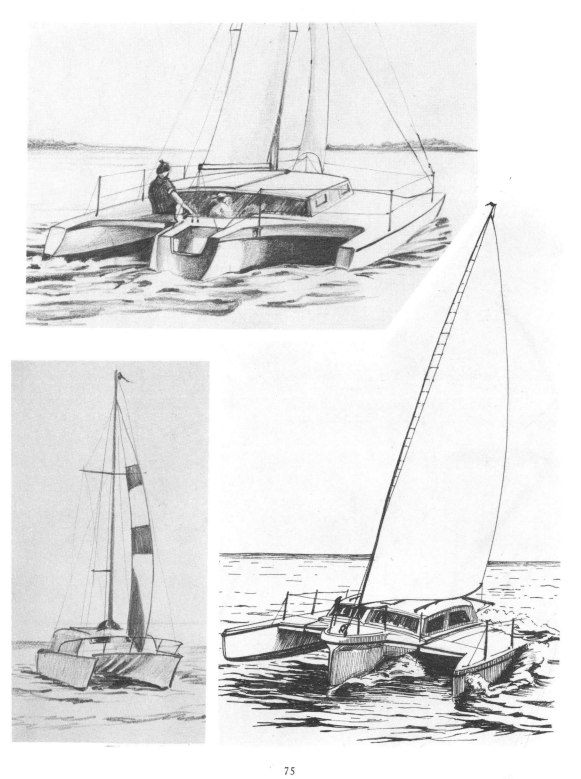

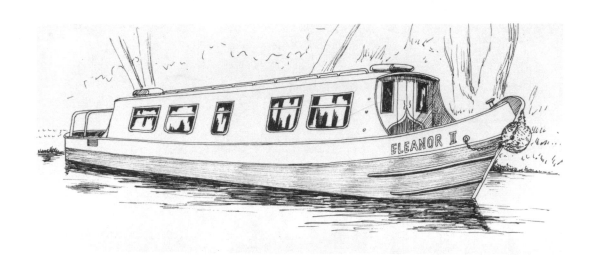

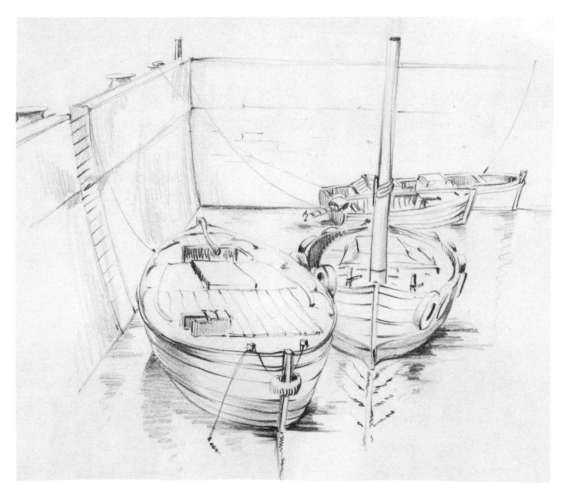

76

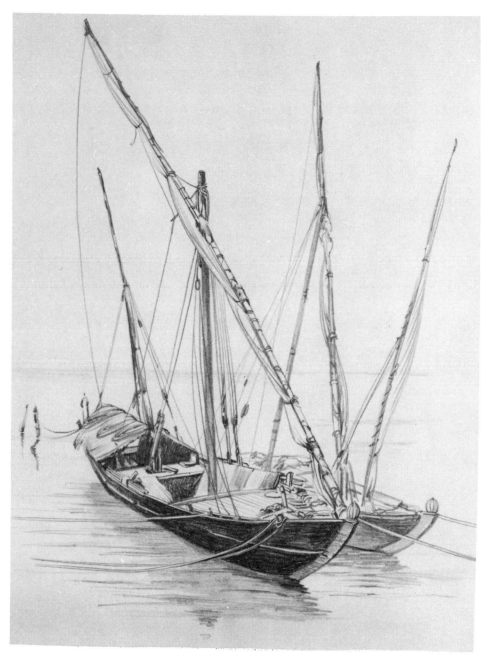

Indian river boats

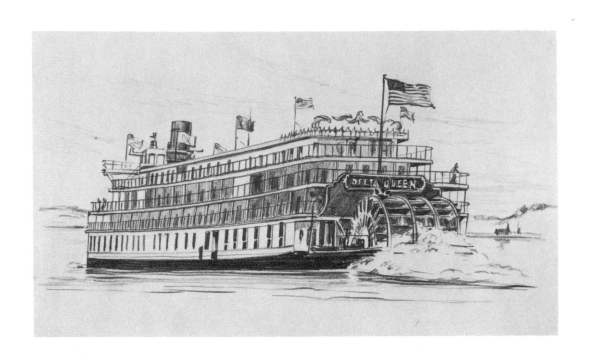

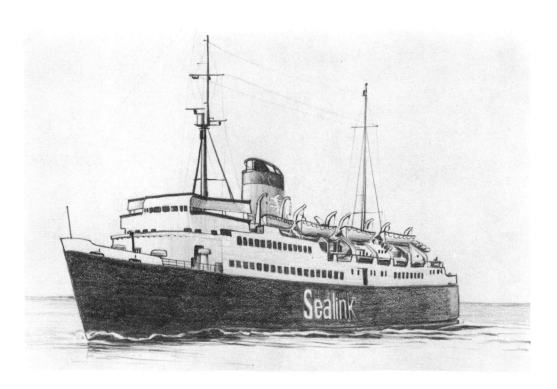

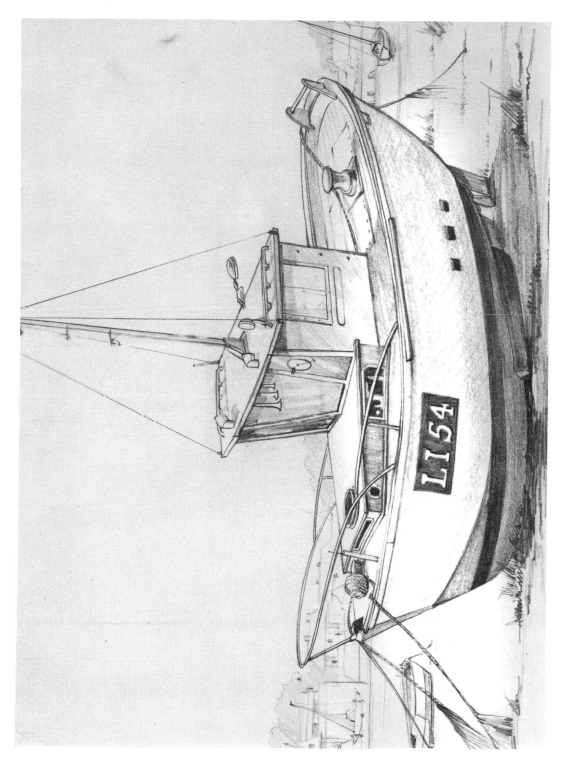

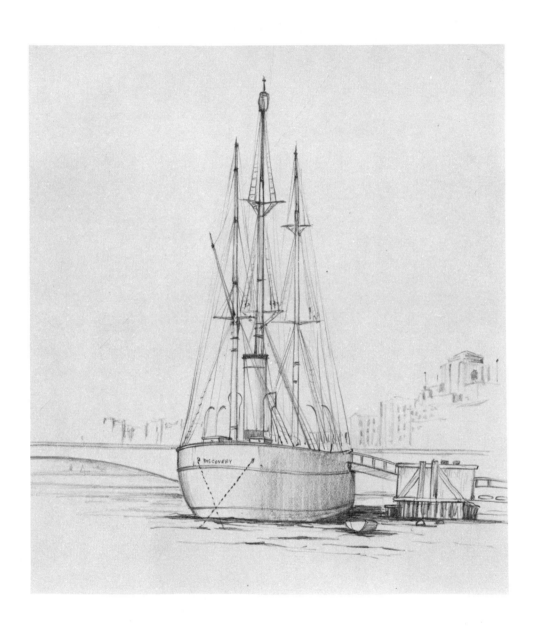

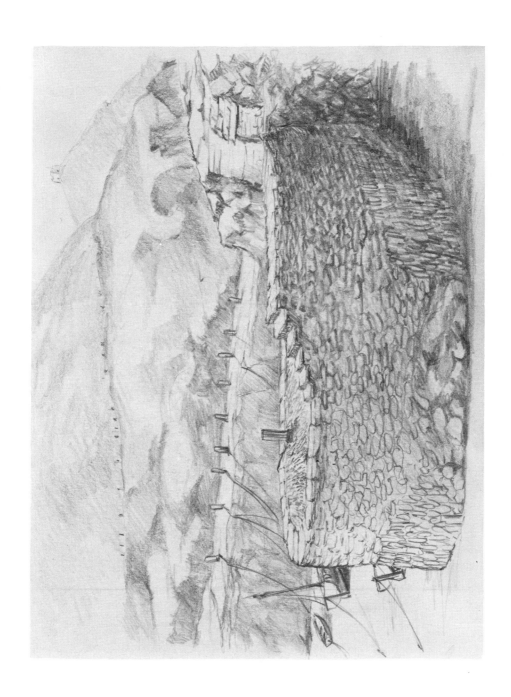

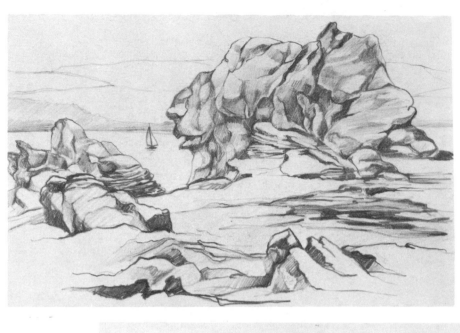

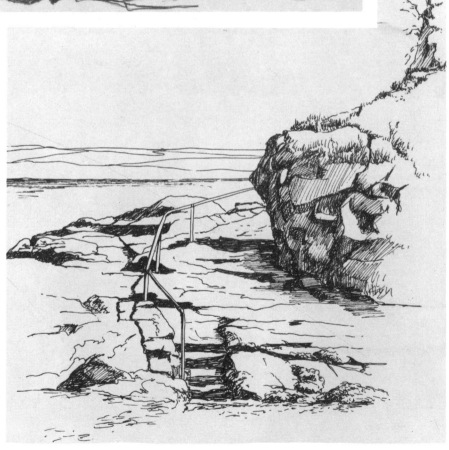

82

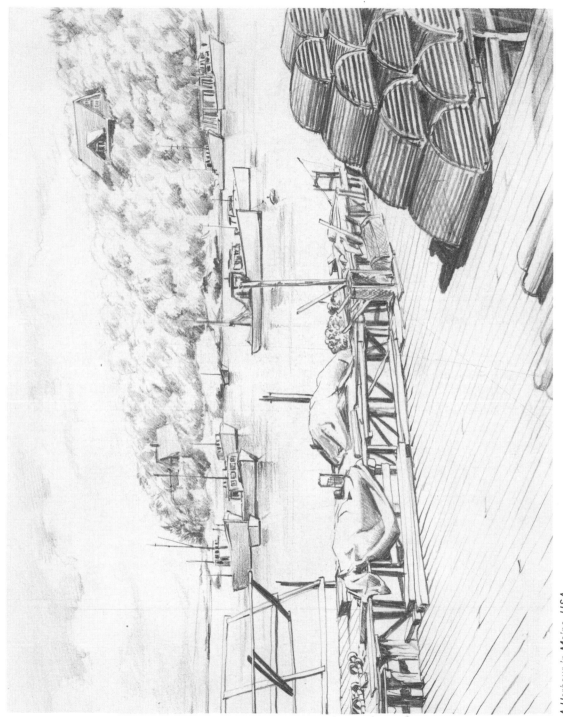

A Harbour in Maine, USA

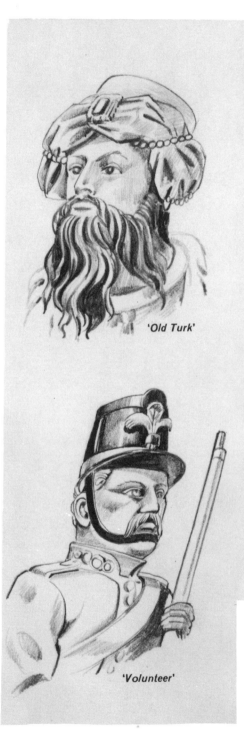

'Old Turk'

'Volunteer'

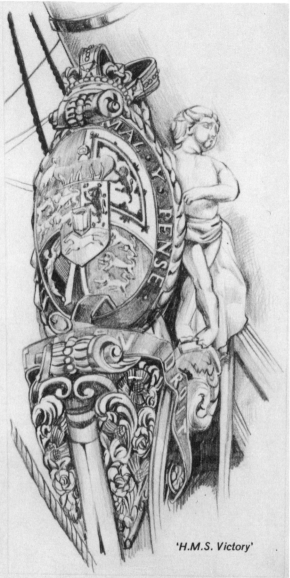

'H.M.S. Victory'

Figure-heads

Some of the most fascinating things to draw on old ships are the figure-heads. They are so beautifully carved and add so much romance to the sea and ships that it is a pure joy to draw them for their own sake if nothing else.

84

'Canberra', Sydney, Australia

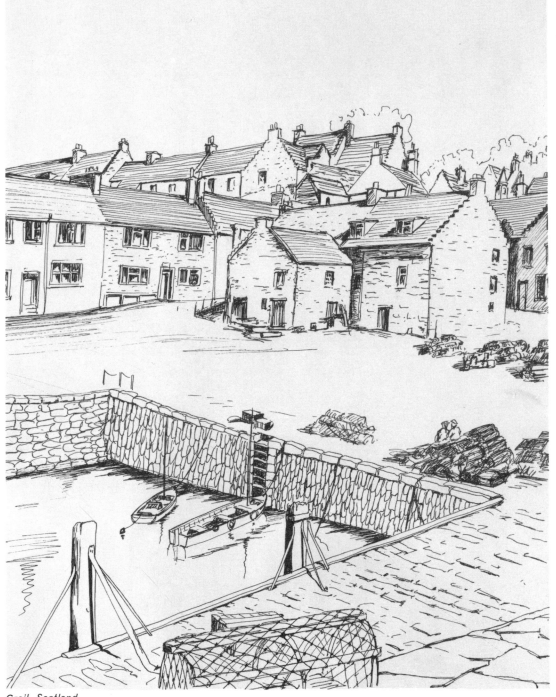

Crail, Scotland

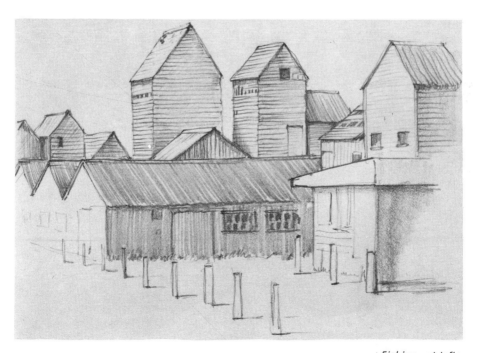

Fishing net lofts

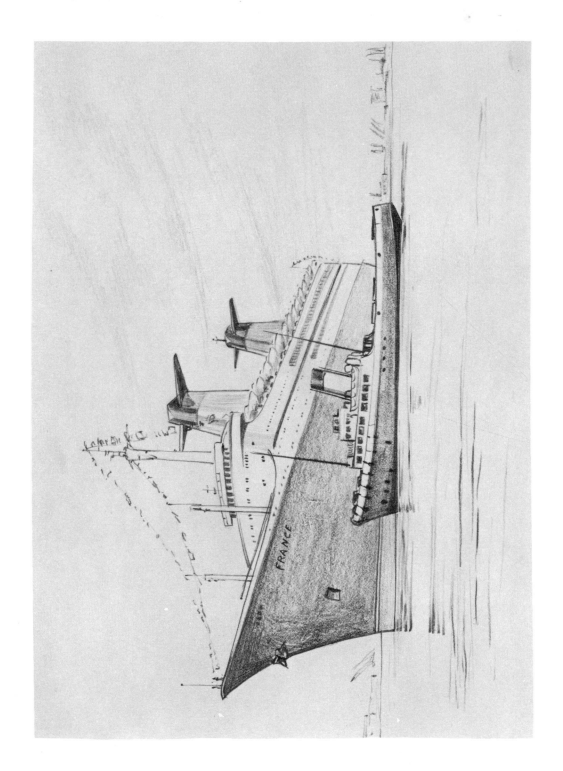

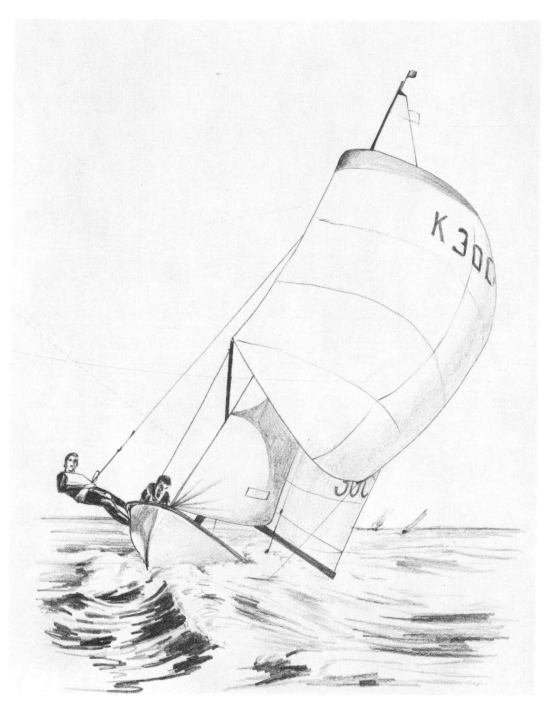

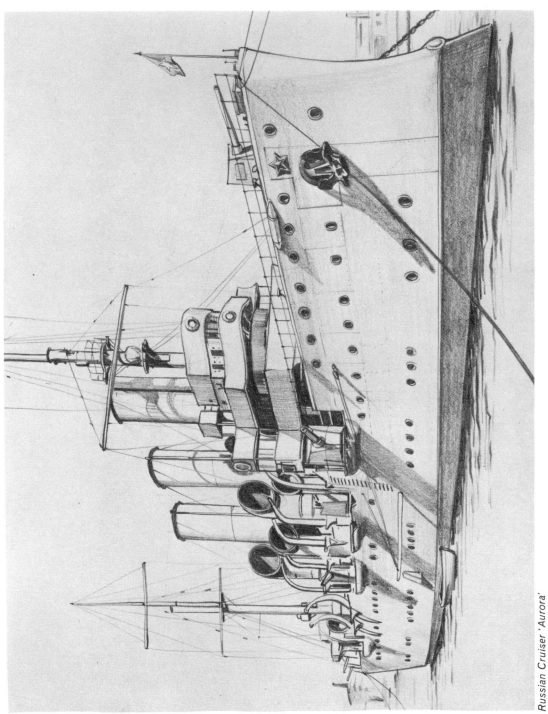

Russian Cruiser 'Aurora'

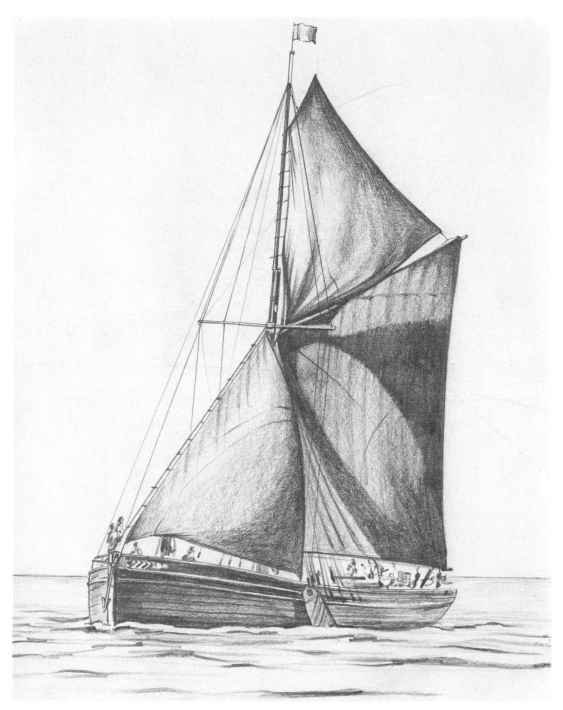

Thames Barge

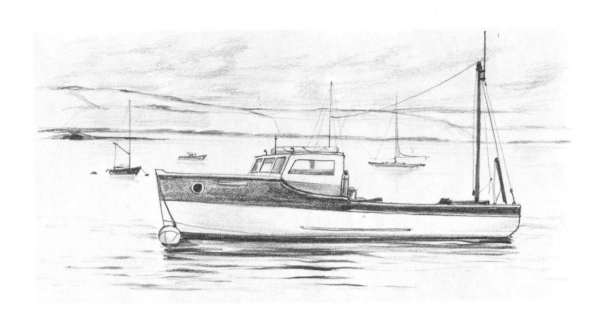

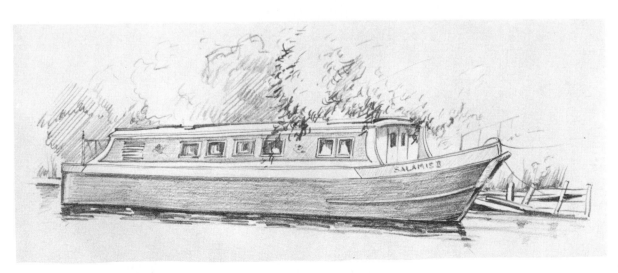

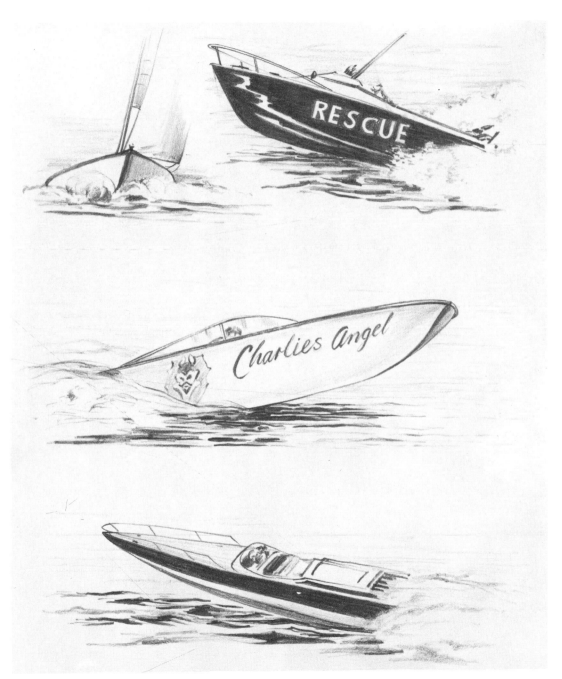

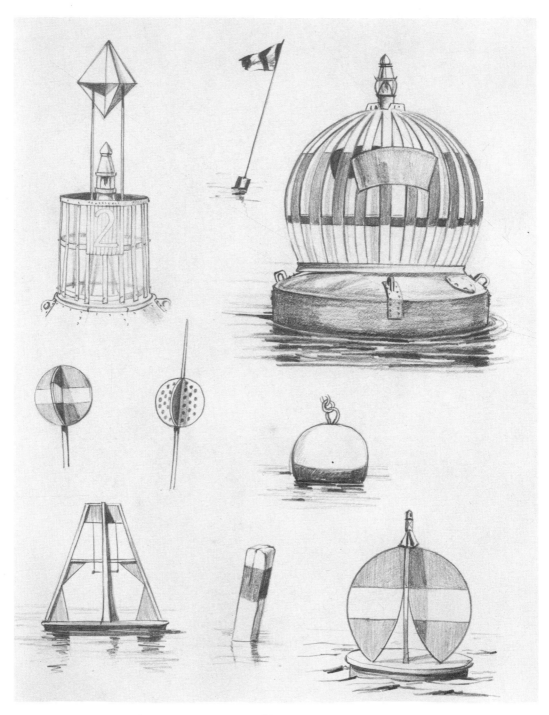

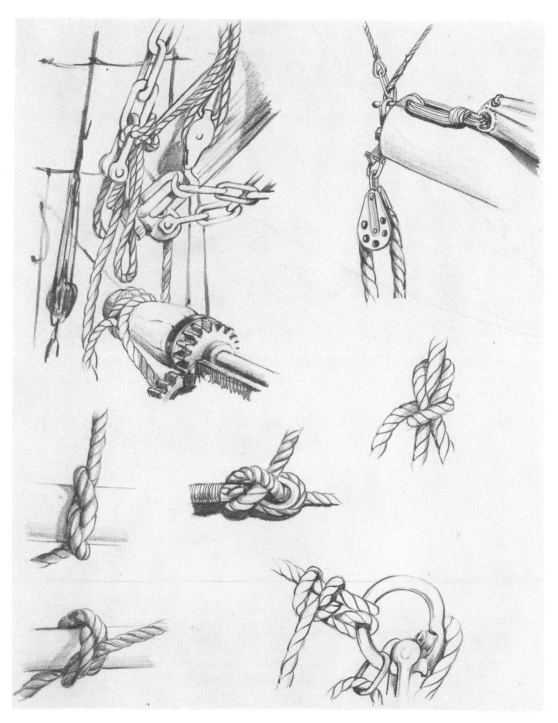

Conclusion

It behoves us as artists to be continually aware of the necessity to practise training our eyes and hands. The talent in all of us must be developed and not allowed to go to waste by disuse. We are privileged to have an art at our finger-tips which can give continual pleasure to ourselves and others.

It is my sincere wish that this book will help act as a spur to go out to observe and draw more, and above all to give a great amount of enjoyment. Although art is a struggle and basically a lonely enterprise, the occasions when one learns and sees something new make it all worth-while.

There is so much beauty in this world if only we can see it and show it to others. It is very important to nurture drawing skills as a gateway to pleasure and self-fulfilment.

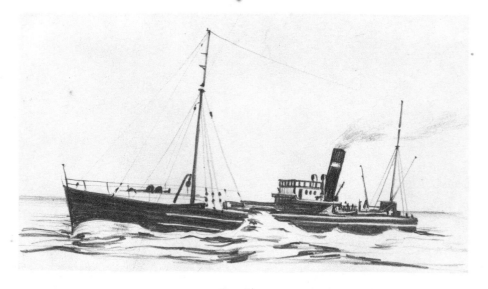